D1483255

PLACE IN RETURN BOX to rem
TO AVOID FINES
MAY BE RECALLED

ART LIBRARY

NK
5017.5
f. P54
1980

LIBRARY
Michigan State
University

MICHIGAN STATE UNIVERSITY
LIBRARY

SEP 09 2016

WITHDRAWN

DO NOT CIRCULATE
ART LIBRARY
ROOM USE ONLY

THE

STAVELOT

TRIPTYCH

OVERDUE FINES:

THE STAVELOT TRIPTYCH

MOSAN ART AND THE

LEGEND OF THE TRUE CROSS

THE PIERPONT MORGAN LIBRARY

OXFORD UNIVERSITY PRESS

NEW YORK · LONDON

DESIGNED PRINTED AND BOUND BY
MERIDEN-STINEHOUR INCORPORATED

Copyright © 1980 by The Pierpont Morgan Library
29 East 36th Street, New York, N.Y. 10016
ISBN 0–19–5202252 LCC 80–08970

CONTENTS

PREFACE

This volume is published on the occasion of the one hundred fiftieth anniversary of the independence of Belgium and as part of that celebration in the United States (the nationwide program, *Belgium Today*). It also acts as a guide to the exhibition of Mosan art—works produced in the vicinity of the Meuse River in Belgium—held at The Pierpont Morgan Library from 26 April to 31 July 1980. Such works, Belgium's unique contribution to Romanesque art, represent one of its most inventive and influential styles. Although Mosan art may be familiar to the general public in Europe, especially through large exhibitions devoted to the subject, like those held in Cologne and Brussels in 1972, and in Rome and Milan in 1973, it is not as well known here. This exhibition is the first in the United States devoted to that art. *The Year 1200* held at The Metropolitan Museum of Art in 1970 included Mosan work but focused on a somewhat later period, whereas our emphasis is on the third quarter of the twelfth century.

In the present book and exhibition we have brought together a select group of Mosan works to demonstrate the artistic milieu in which the Stavelot Triptych, one of the supreme masterpieces of Romanesque art, was created. These works exemplify three distinctive areas of achievement: (1) *Champlevé enamel*—represented in the Stavelot Triptych and three plaques from the Metropolitan Museum. (2) *Repoussé work*—the superb Reliquary Triptych of the True Cross from Liège, and the Reliquary in the shape of a gable from Brussels. The Reliquary Triptych, rich in Last Judgment iconography, is

complemented by the thematically related Reliquary Triptych of the True Cross from a private collection in New York. (3) *Manuscript illumination*—the Averbode Gospels, one of the greatest works of Mosan illumination, with the Mosan Psalter Fragment from Berlin and the St. Trond Lectionary (Morgan Library), show the close contacts at this time between illuminators and goldsmiths, who must have used common models. These artistic interchanges are documented in this volume.

In addition, there are objects associated with the Imperial Abbey of Stavelot, and more specifically with Wibald, its enlightened abbot from 1130 to 1158, for it is likely that he commissioned the Stavelot Triptych. A *Life and Miracles of St. Remaclus*, an illustrated work of Josephus, and Wibald's own Sacramentary, all of which belonged to the abbey, are included, as well as a large drawing of the great retable dedicated to Remaclus (now destroyed) which Wibald commissioned. The monastic complex, except for the base of the church tower, has not survived, but there is a drawing and an engraving depicting the abbey buildings as they existed in the eighteenth century when the wonderful Romanesque church was still intact.

The Stavelot Triptych is the earliest surviving reliquary of the True Cross with illustrations from the Legend of the True Cross and is unique in that it unites in a single work of art Eastern and Western (Byzantine and European) iconographic traditions of the Legend as they existed in the middle of the twelfth century. Therefore a section of this book and the exhibition has been devoted

to that story, one of the most important and comprehensive of all mediaeval legends, spanning as it does biblical history from the Fall of Man until the seventh century when Heraclius restored the Holy Wood to Jerusalem. This section draws chiefly on the holdings of the Morgan Library, but it amply illustrates the various liturgical and secular manuscripts and books which contain pictures relating to the Legend. For convenience, we have reprinted translations of parts of the *Golden Legend* of Jacobus de Voragine which relate to the story of the True Cross.

We have also included the first results of a recent archaeological investigation of the Stavelot Triptych and have described and reproduced the hitherto unknown relics contained in the smaller of its two Byzantine triptychs. The Triptych has for the first time been reproduced in detail in color.

Research on the Stavelot Triptych has been carried on for a number of years by William Voelkle, Associate Curator of Mediaeval and Renaissance Manuscripts in the Morgan Library, and he has been primarily responsible for the writing of this volume and for the exhibition. Showing the Stavelot Triptych in the context of Mosan art was first suggested to us by Dr. Herman Liebaers, Grand Maréchal de la Cour of Belgium. Professor Jacques Stiennon, of the University of Liège, and his assistants have greatly helped in preparing the material concerning the loans from Belgium, and Professor John H. Plummer of Princeton University and the Morgan Library has assisted us in editing the volume. The photographs of the Stavelot Triptych (and the Morgan manuscripts) were made by Charles V. Passela at the Morgan Library.

Various divisions of the Belgian government and directors and curators of state museums, libraries, and archives have helped with the exhibition and this publication. We have received a very generous grant from the Museums Program of the National Endowment for the Humanities, and, like all exhibitions at the Morgan Library, this one has received assistance from the Institute of Museum Services in the Department of Health, Education and Welfare, as well as from the New York State Council on the Arts. Groupe Bruxelles Lambert S.A.–Banque Bruxelles Lambert and Compagnie Bruxelles Lambert, with their affiliates in New York, have helped with the sponsorship of the exhibition. Mr. Brooke Lappin, National Program Director of *Belgium Today*, has given us much good counsel.

Lenders to the exhibition (and the members of their staffs who have been of special aid) are: Bernice B. Carton, New York; an anonymous private collection, New York; Berlin, Kupferstichkabinett (Fedja Anzelewski); Brussels, Bibliothèque Royale Albert Ier (Martin Wittek); Brussels, Musées Royaux d'Art et d'Histoire (René de Roo, Josy Muller); Huy, Trésor de la Collégiale Notre-Dame (Albert Lemeunier); Liège, Archives de l'État; Liège, Bibliothèque de l'Université; Liège, Église de la Sainte Croix; New York, The Metropolitan Museum of Art (Margaret Frazer, Charles Little, Jean Mailey, Philippe de Montebello, Roger S. Wieck, William D. Wixom); Stavelot, Musée de l'Ancienne Abbaye; Stavelot, Trésor de l'Église Primaire.

Others who have been helpful are: Lawrence Arbach, Priscilla C. Barker, Linda Bell, Bernhard Bischoff, Ronnie Boriskin, the late Robert Branner, Joyce Brodsky, Hans Joachim Brüning, Marie de Briey, Lucie de Myttenaere, Cara Dufour Denison, Mervin Dilts, Giannalisa Feltrinelli, Théo Galle, Sara Feldman Guérin, Garman Harbottle, Timothy Herstein, Mimi M. Hollanda, Franz-Josef Jakobi, John James, William Kmet, Dietrich Kötzsche, James Kraft, Hans Wolfgang Kuhn, James T. Lang, Francis S. Mason, Cheryl McClenney, Patricia Ann McFate, M. Sammye Miller, Sigrid Müller-Christensen, Paul Needham, Beatrice Rehl, Patricia Reyes, Edward V. Sayre, Walter Schulten, Meyer Schapiro, Jane V. Shoaf, Peter Solmssen, Felice Stampfle, Raymond W. Stoenner, Hanns Swarzenski, Philippe Verdier, Amber Verrycken, Deborah Winard, David W. Wright, and Alexander Jensen Yow.

CHARLES RYSKAMP
Director

8

THE STAVELOT TRIPTYCH

THE STAVELOT TRIPTYCH AND MOSAN ART

The Stavelot Triptych is one of the masterpieces of Romanesque art (1–8). Its enamels are among the finest and best preserved of those made during the twelfth century in the Mosan region of what is now Belgium. The Mosan style or styles of this period decisively influenced the art of Germany, France, and England, and Mosan goldsmiths and enamelers were called to various parts of Europe on commissions from emperors, kings, bishops, and abbots.

The word "Mosan" is derived from the name of the Meuse or Maas River which rises on the Langres Plateau in France and empties into the Rhine estuary in the Netherlands. But when applied to mediaeval art, Mosan refers more narrowly to works produced along the prosperous Belgian stretch of the river and its tributaries, particularly those regions falling within the diocese of Liège. This diocese was bounded by those of Cologne on the east, Trier and Reims on the south, Cambrai on the west, and Utrecht on the north. While a number of the centers that produced this art have with some probability been identified, notably Liège, Maastricht, and Stavelot, most of the works can be localized only in the general region.

The chronological limits of Mosan art are ill-defined, for the word "Mosan" is used by some authors for the art of that region even into the eighteenth century. For most people, however, the term brings to mind the series of great Romanesque works, made between the late eleventh century and the early thirteenth, and it will be used in this sense here.

It is to a rather distinct group of Mosan works in metal and enamel made around the middle of the twelfth century that the Stavelot Triptych is most closely related. This group includes the Alexander Reliquary in the Musées Royaux d'Art et d'Histoire, Brussels (14–16); the two surviving enamel medallions from the Remaclus Retable now in the Museum für Kunsthandwerk in Frankfurt am Main (12) and in the Kunstgewerbemuseum in Berlin (13); another enamel medallion in the Trésor de la Collégiale Notre-Dame in Huy (11); and a series of eleven or twelve square enamel plaques that probably come from a single project, but are now scattered in several collections: four in The Metropolitan Museum of Art, New York (18–20); four in the Victoria and Albert Museum, London; one in the British Museum, London (17); and two or three in the Louvre, Paris.

Two of these works, the Alexander Reliquary and the Remaclus Retable, were made for Abbot Wibald of Stavelot, but it is uncertain where they were made, whether at Stavelot or in an urban center such as Liège. The Alexander Reliquary was completed in 1145, and in April of that year the relics of the saint were deposited in it. The great Remaclus Retable, which measured over nine feet in both height and width and was surely Wibald's most ambitious commission for his abbey, was later destroyed. There are no documents for dating the Retable, and the two surviving medallions, though they give some idea of the high quality of the original, do not permit a very precise dating, but they were probably made after the

Alexander Reliquary of 1145 and before Wibald's death in 1158. None of the other related enamels can be precisely dated, nor can the Stavelot Triptych itself, unless one accepts the traditional surmise that the two Byzantine reliquaries in its center were acquired by Wibald in Constantinople and were installed between his return in 1156 and his death in 1158. Conjectural as the story is, this date cannot be far from the truth.

PROVENANCE, PATRON, AND ARTIST

The early history of the Triptych is unknown, and there is no early documentation linking it with either Stavelot or Wibald. Not until the time of the French Revolution do we pick up its trail, for apparently it was taken from Stavelot by Célestin Thys, the last Prince-Abbot of Stavelot, when he fled to Hanau, near Frankfurt, where he died in 1796. Nearly a century later it was "discovered" in the house of the Waltz family in whose possession it remained until 1909, when it was offered for sale by Durlacher Brothers of London. In the summer of 1910, on the advice of Sir Charles Hercules Read of the British Museum, it was purchased by John Pierpont Morgan. It remained on loan in the British Museum until after Morgan's death in 1913 and arrived at its present home in the spring of the following year.

It is likely, although again documentary evidence is lacking, that the Triptych was commissioned by Wibald, the enlightened abbot of the Imperial Benedictine Abbey of Stavelot (1130–1158). Beyond his concern for the welfare, wealth, and adornment of Stavelot, Wibald played an important role in the ecclesiastical and political affairs of the day. After 1146 he was concurrently abbot of another major imperial abbey, that of Corvey in Westphalia, and for a brief time was even abbot of Monte Cassino. In politics he acted as advisor and agent for three successive Holy Roman Emperors: Lothair II (1125–1137), Conrad III (1138–1152), and Frederick I Barbarossa (1152–1190). He accompanied Lothair to Italy in 1136–1137, helped manage the affairs of the empire for

Conrad when he was away on the crusades, and was sent by Barbarossa on two missions to the court of Manuel I Comnenus in Constantinople. On the first of these trips, during the winter of 1155–1156, he negotiated for the marriage of Frederick with Comnenus' niece. While returning from the second mission of 1157–1158, he died at Monastir, Macedonia, on 19 July 1158; but it was not until a year later that his body was brought back to Stavelot by his brother Erlebald and was buried before the main altar of his beloved abbey church.

About Wibald's activities we are well informed—over four hundred of his letters have been preserved—yet very little has survived that can be connected with certainty to his artistic patronage. Indeed, the only two projects that are documented have already been mentioned. One of these is the large gold and enamel retable dedicated to St. Remaclus, a seventh-century founder of Stavelot. Although largely destroyed, its essential features and dedicatory inscription have been preserved in a detailed drawing of 1661 (10). Depicted under the gable over the shrine are the two superb enamel roundels that survive: one, showing OPERATIO (13), a personification of good works, is in Berlin (formerly in the Baron von Hirsch Collection); the other, showing FIDES BABTISMUS (12), a personification of faith holding a baptismal font, is in Frankfurt. Nothing else remains, except for two enameled inscriptions that are now in the Trésor de l'Église Primaire at Stavelot and have been identified from the drawing. Although the main dedicatory inscription states that Wibald was responsible for the Retable, no date is included. The other commission, the Head Reliquary of Pope Alexander (14–16), is not only documented, but is also securely dated. As we have said, it must have been completed before 13 April 1145, when the relics of the saint and a dated certificate of translation mentioning Wibald were placed within it.

The Triptych was probably made in the same workshop as the Alexander Reliquary and the Remaclus Retable. Because of this, its Stavelot provenance, and approximate stylistic date, it too has been connected with

Wibald. His patronage might well account for the two Byzantine triptychs enshrined in its central panel (6–7). These are generally assumed, though proof is lacking, to have been presented by the Byzantine Emperor, Manuel I Comnenus, to Wibald during his 1155–1156 mission. If true, the Triptych would date from 1156–1158 and would be one of Wibald's finest commissions and perhaps his last.

None of Wibald's works can be specifically connected with the goldsmith whom he addresses simply as "G" in his famous letter of 1148. Unfortunately, the letter tells us very little about this goldsmith, other than that certain unspecified work had not yet been completed, that he was a lay artist of some intelligence, and that he had a family. Since the letter mentions work in progress, it is possible that "G" may have been employed by Wibald in 1145, when the Alexander Reliquary was completed. However, there is no evidence that "G" was in fact connected with that commission, and if "G" made that Reliquary, he almost certainly did not make the Triptych, since it appears to be by a different hand. The identification of "G" with Godefroid de Huy or Godefroid de Claire, as is commonly assumed, cannot be supported. The shrines of Saints Domitian and Mangold, the only documented works by Godefroid, contain no enamels and are not stylistically connected with any of Wibald's commissions. Until new evidence appears, the name of no artist can be convincingly attached to our Triptych.

DESCRIPTION OF THE WHOLE TRIPTYCH

The opulence of the Triptych, with its copper-gilt frames and light-catching cusps, silver pearls and columns, gilt-brass capitals and bases, *vernis brun* domes, semi-precious stones, intaglio gems, beads, and exquisite champlevé and cloisonné enamels, conveys an astonishing sense of preciousness and enrichment. Such embellishment was, of course, appropriate for the Triptych's function as a reliquary containing relics of the central object of the Christian faith, the True Cross.

The Stavelot Triptych is one of the earliest Western reliquaries of the True Cross in triptych form and must have helped to set the fashion for such triptychs in the Liège diocese during the second half of the twelfth century. This form probably originated in Byzantium, where it had been in use for at least two centuries for devotional ivories (51) and True Cross reliquaries. But the immediate sources for the form of our Triptych were probably the two Byzantine triptychs mounted in its central panel. The enamels of the upper of these triptychs depict the Annunciation and the Crucifixion, while those of the lower one show the four Evangelists, four Byzantine military saints, and, flanking the relic of the True Cross, Constantine and Helena with two archangels. These enamels are all executed in the cloisonné technique, in which the designs are formed by narrow gold strips, called cloisons, soldered together to form compartments for the enamel.

The Stavelot Triptych is also the earliest surviving reliquary of the True Cross with scenes from the Legend of the True Cross. The Legend is told in the six enamel medallions, divided into sets of three on the two wings. As in stained glass windows, the roundels on both wings read upward from the bottom to the top: beginning on the left with Constantine's vision, his defeat of Maxentius, and his baptism; and continuing on the right with Helena's interrogation of the Jews, the finding of the three crosses, and the determination of the True Cross. These enamels are executed in the champlevé technique, which differs from the cloisonné in that the enamel is contained in cavities hollowed out of a thick copper plate, rather than in cloisons. In these, as in most Mosan enamels, two or more colors, usually including white, were often mingled in the same cavity to modulate the color and to suggest modeling. This Mosan technique was already established by 1145, for it occurs on the Alexander Reliquary, along with the Mosan invention of simply engraving the heads and hands and leaving the flesh areas in gilt. The technique of our roundels, which measure about $4\frac{1}{4}$ inches in diameter, is more advanced

than that on the Alexander Reliquary, where transparent enamel is not used. To bring out the transparency of the enamels, the Stavelot artist occasionally placed small pieces of foil beneath the enamel, as in the green of the True Cross, in order to catch and reflect the light as a gem does (3). This effect, which is similar to that of stained glass, is also used in the red areas of Helena's robe in the interrogation scene (3). But the most extraordinary effect is that of the flickering flames in the same roundel, achieved in part by the unevenness of the foil.

Framing the medallions are silver columns supporting domes that are decorated in the *vernis* or *émail brun* technique, in which copper, coated with linseed oil, has been fired to a rich dark brown color. Here two different, though similar, trellis designs have been incised in the copper and then gilded (4–5).

The decorated gilt panels between the medallions, with their silver pearls, light-catching cavities and cabochons, are virtually identical with those on the Alexander Reliquary (16), indicating that both were made in the same workshop. The capitals and bases of the silver columns, which were cast in brass and then gilded, resemble contemporary Romanesque capitals found in the churches of the Liège diocese, as well as those on contemporary Mosan metalwork, for example, the Hadelin Shrine in the church of Saint Martin in Visé and the Pentecost Retable in the Cluny Museum, Paris. The architectural structure suggests one of the many ciboria or oratories of the True Cross, such as the one erected by Pope Symmachus (498–514) near the font in Old Saint Peter's.

On the domes are two carefully executed inscriptions, whose texts will be discussed later. Like the inscriptions on the Remaclus Retable (10), their classicizing forms may reflect Wibald's love for the classics and for classical inscriptions.

THE CONSTANTINE WING

The Vision of Constantine (2, 9)

This roundel and the two others devoted to Constantine are not as dependent on Eusebius' authoritative *Life of Constantine* as one might expect. According to the *Life*, written shortly after the emperor's death in 337, Constantine was preparing in the autumn of 312 to do battle with Maxentius. While he was pondering the outcome of the conflict, he saw a cross of light in the heavens above the midday sun. The cross was inscribed with the words "By this conquer." That evening Christ appeared to him in his sleep and directed him to make his standard.

The enamel, however, follows more closely the account given in the supplementary material added by Rufinus to his translation of the *Ecclesiastical History* by Eusebius, which was compiled some sixty years later. There Constantine is described as having seen the cross in a dream, and, when he awakened in terror, an angel appeared to him and said, "*In hoc vince*" ("In this conquer"). In the medallion, Constantine is still asleep, and the event takes place in a triple-domed palace, rather than in an encampment. The vision of the cross appears above, but on the same axis as the central dome and its hanging crown, perhaps a crown-type lamp. On the right, an angel points to the vision in the sky and exclaims, "IN HOC VINCE," these words being inscribed on his scroll. Here, as in the other medallions, there are two types of inscriptions: those on the gilt backgrounds, which identify persons, places, things, or events; and those representing spoken words, which are always placed on scrolls held by the speakers. These scrolls occur only on the bottom medallions of the wings, and the scroll of the angelic voice is more elaborate than those of Helena and the Jew on the right wing (3).

Two distinct traditions for depicting the vision and Constantine can be discerned, one Western and the other Eastern. In the earliest example known, from the early ninth-century Wessobrunn Prayerbook in Munich (23),

the Western tradition is already firmly established. The sleeping Constantine's head rests on a pillow, he is generally covered, and a nimbed angel is present. Constantine is sometimes crowned, but never has a halo. Although at least one observer has said that Constantine is haloed in the Stavelot roundel, the supposed halo is only a green pillow. In addition to the way Constantine props up his head, the two examples also share another remarkable detail, the foot stretched against the bedstead.

The Eastern or Byzantine tradition, represented in the late ninth-century Homilies of Gregory Nazianzus in the Bibliothèque Nationale (54), also shows Constantine asleep, but there he is in full imperial regalia, crowned, and haloed. The vision follows more closely the account of Eusebius, for the angel is not present. Generally in Byzantine art, Constantine is depicted in imperial garments, crowned, and haloed, and so he appears in the Byzantine enamel in the center of the Stavelot Triptych itself (7). This imperial and haloed Constantine contrasts strikingly with his more humble and informal Western counterpart in the roundel who is shown in a nightshirt. The explanation is liturgical and perhaps also political. Constantine, unlike his mother Helena, never achieved the status of a saint in the West, while in Byzantium both of them appear as saints in the eighth-century calendar known as the Menology of Constantinople. Receptive as the West was to Byzantine artistic influences, it resisted that influence when the images conflicted with its own liturgy.

The composition is strikingly close to that on a page in the so-called Mosan Psalter Fragment in Berlin, which depicts the Presentation in the Temple and the Angel Appearing to Joseph (24). The kinship between the two angels, especially their facial types, the color of their wings, and their relationship to the architecture, leaves little doubt that some connection existed between the two works. A third composition, the Angel Appearing to St. Trudo on the Remaclus Retable (10), is also similar, but the degree of similarity is difficult to judge, since the original composition is known only through the hand

of a seventeenth-century draftsman. These similarities suggest that all of them derive from a common model, or that one influenced the other two, but the dates for all have been much disputed, the sequence in which they were made is uncertain, and all are nearly contemporary.

The Battle between Constantine and Maxentius (2)

In the second medallion, Constantine and his soldiers rout Maxentius and his forces in the most active and dramatic scene on the Triptych. The victory was attributed to the miraculous power of the cross, here labeled "LABARUM," which Constantine had modeled after his vision and carried into battle. This precedent was followed by later Byzantine emperors, who carried a relic of the True Cross into battle or on various ceremonial occasions. In the case of one military victory, which occurred in 1164 during the reign of Comnenus, the event was even commemorated in the liturgy with a new feast, the Procession of the Holy Cross (1 August).

The details of the medallion do not conform with the account given by Eusebius in his *Ecclesiastical History*, even though a copy was listed in the 1105 inventory of the library at Stavelot. In that work he clearly states that Maxentius actually died by drowning, when the Milvian Bridge, over which he was fleeing, collapsed. By analogy, Eusebius regarded Constantine as a new Moses and compared his miraculous victory with the drowning of Pharaoh's men and chariots in the Red Sea. This medallion, like the earlier representations, is less concerned with historical accuracy or the Eusebian analogy than with aggrandizing the emperor and personalizing his victory. Even in the Homilies of Gregory Nazianzus (54), which correctly includes the bridge, Constantine single-handedly routs the enemy and pierces Maxentius with his lance. Similarly, in this medallion, the tip of Constantine's lance is embedded in the chest of Maxentius.

The composition has been compared with two others. Since these depict different battles and were made in

other countries, the composition appears to follow a widespread convention for depicting battles. One of these scenes occurs in a "Life and Miracles of Saint Edmund," an English manuscript of about 1130 in The Pierpont Morgan Library (25); it includes such details as the spotted horses, the arrangement of the lances, and a man brandishing a sword. The other battle scene, from the crusade window at Saint-Denis, is more strikingly similar because of its circular format. Unfortunately, it was a victim of the French Revolution, and its composition is known only through Montfaucon's engraving of 1729 (26). The date of this window and its connection, if any, with the second medallion are uncertain. That the window is not mentioned in Abbot Suger's inventory of 1146–1147 has been taken as evidence of a considerably later date; however, some have argued that the Stavelot artist was influenced by this window, and others that he was its designer. While it may be dangerous to reach any conclusions based on the engraving, our artist was clearly superior in his use of the tondo format and dramatic postures, especially in the two figures at the bottom.

An even closer composition, illustrating the Old Testament subject of Abraham Pursuing the Hostile Kings, is found in the Mosan Psalter Fragment (27). None of the other battle scenes is as close as this one: only here do the figures look out at the spectator; and the groups of soldiers, the facial types, the head framed by the brandished sword, the horses, and even the color of Constantine's shield are the same. One important difference in the Morgan roundel is the crusader character given by the standard bearer carrying the triple pennant of the crusades. The form of the pennant is nearly identical to that in the crusade window (26). This crusader element may be related to Wibald's own activities on behalf of Conrad III, while the emperor was participating in the Second Crusade.

Above the third medallion is a large carnelian gem (28–29) of ancient origin, incised with the scene of a horseman killing a serpent with a cross-surmounted spear. During the Middle Ages there existed a marked taste for such classical gems, which were frequently included on book covers, reliquaries, and other liturgical objects. In most cases the mediaeval artists paid little attention to the subject matter of the gems, but there can be no doubt that this intaglio was included and so placed because of its thematic connection with the victory of Constantine. The subject of the gem recalls Eusebius' description of the representation of "Constantine's Victory over the Enemies of the Church" at the entrance of his Imperial Palace at Constantinople. There he appeared, surrounded by his sons, trampling and transfixing a dragon which represented the enemy. This symbolism of the dragon or serpent was further popularized by Constantine's coinage, where the image of the labarum set on a serpent appeared after about 333. Although the gem most closely resembles Palestinian and Syrian types which were used as magical amulets, Wibald probably regarded the gem as generically classical. His interest in antiquity was not limited to gems, as he read the classics avidly, quoted from them in his letters, and ordered copies of them, especially the works of Cicero. In his monastery at Corvey, according to a letter written in 1149, he included a Greek inscription from the Temple of Apollo at Delphi. The inscription, which occurred next to his own name above the south door, was the famous maxim "Know thyself."

The Baptism of Constantine (4)

As with Constantine's Vision, the accounts and pictorial traditions of his baptism also differ. Eusebius, in his *Life of Constantine*, states that the emperor was baptized shortly before his death in 337 by the Arian bishop of Nicomedia, whose name was also Eusebius. This late baptism was favored by St. Ambrose and St. Jerome; both, like Eusebius, gave Constantine's desire to be baptized in the Jordan as a reason for the postponement. The church did not wish to encourage the practice of such late baptisms, and, for various ecclesiastical and political reasons, it readily accepted as genuine the apocryphal fifth-century *Acts of Silvester*, in which Pope Silvester is said to

have converted and baptized Constantine earlier in life. Through these *Acts*, which may well have been written in Rome itself, the papacy assumed a central role in Constantine's baptism and, by implication, in the triumph of the church that followed. This account gained great popularity; it was incorporated and illustrated in various liturgical texts (**30, 32**). For example, the readings for the Divine Office for the feast of Saint Silvester (31 December) were, until recently, based in part upon these *Acts*.

The medallion clearly follows the Silvester tradition, for the baptism is administered by a bishop labeled "SILVESTER PAPA." The setting, moreover, suggests details of the Lateran Baptistry, where Roman tradition placed Constantine's baptism, and which Wibald must surely have visited in Rome. There he would have seen "Constantine's font," which, according to the *Liber Pontificalis*, was made of porphyry, the material suggested in the enamel by the superb speckling technique. Likewise, the columns flanking the medallion and supporting the dome above it recall the colonnaded structure that surrounded the Lateran font, as does the miniature in an extensive Silvester cycle in Turin (**31**).

According to the *Acts* a great light surrounded Constantine during his baptism. The light is indicated in the medallion by the three rays emanating from the Divine Hand above; the divine presence, rare in Constantine's baptism but common in Mosan art, elevates and sanctifies the event. Two other small, yet significant, details in the enamel are the vials held by the cleric assisting Silvester. Two such vials also occur in the earliest extant depiction of the baptism, that in the late tenth-century Sacramentary of Bishop Warmundus in Ivrea (**30**). Within the cycle of the Sacramentary, as argued by Robert Deshman, the two vials indicate that the "baptismal anointing of Constantine was also an imperial sacring which conferred the temporal powers of *rex et sacerdos*." In the Morgan Triptych it is uncertain whether or not these dual powers, secular and ecclesiastical, are implied by the vials, or what relations between state and church are intended.

While the Divine Hand and rays suggest the direct, divine sanctification of Constantine's power and through him of the Holy Roman Emperors, the nature of that power is uncertain, and other references to Constantine's kingship have been consistently played down in all of the medallions. He is never crowned or referred to as *Rex*, even though Helena is always crowned and twice labeled "REGINA." On the other hand, the two vials are held awaiting the administration by the pope and thus may imply that their dual powers are bestowed on the emperor by the papacy. This ambiguity may be connected with the contemporary rivalry between the empire and the papacy and with Wibald's own views about the struggle. The conflict turned in part on the so-called Donation of Constantine, the famous eighth-century forgery that was probably written in the papal chancery, in which Constantine granted certain sweeping privileges and secular powers to Pope Silvester and his successors. The Donation was used by the popes to elevate and justify the secular powers of the church, while the Holy Roman Emperors used it to diminish them. For instance, in 1159, in an argument with Pope Adrian IV regarding papal power, Frederick Barbarossa asserted that it was not he who owed fealty to the pope, but that the pope owed it to him, because it was Constantine who gave the papacy its powers in the first place. Thus, the Donation was as equivocal as is the political interpretation of the baptismal medallion. Such ambivalence must also have been present in Wibald's mind because of his double allegiance to the emperor and the papacy.

However one reads those political implications, there remains something miraculous about the divine rays falling on Constantine. Indeed, according to the *Acts of Silvester*, a miracle had occurred, for Constantine was thereby cured of the leprosy caused by his persecutions of Christians. He is compared by Silvester to the Old Testament Naaman (4 Kings v), who was miraculously cured of his leprosy in the Jordan River. This comparison must have been known in Stavelot, for it was repeated by Berengosus of Trier in his *De laude et inventione sanctae crucis* of

1112, and in a Mosan enamel of Naaman's cure (17) the figure of Naaman is surprisingly like our Constantine, and one of the rays from the Divine Hand is labeled "CURATIO NAMAM." As the left wing of the Triptych ends with these implications of Constantine's miraculous cure, so it obviously parallels the end of the Helena cycle on the right, where the top medallion shows the dead youth revived by the True Cross, a miracle also accompanied by the Divine Hand and triple rays (5).

THE HELENA WING

After Constantine's baptism, according to the *Acts of Silvester*, the pope converted Helena, who then went in search of the True Cross, the subject of the right wing. As in the Constantine story, the various accounts of the discovery of the True Cross are confusing and contradictory, and some early writers such as Eusebius in his *Life of Constantine* and St. Jerome, who lived in the Holy Land, are strangely silent about Helena's discovery.

About 347, Cyril of Jerusalem mentioned in a lecture that the Holy Wood of the Cross had by then filled the whole world; and in a letter of 351 to Constantius II, Cyril wrote that the salvation-bearing wood of the Cross was found in Jerusalem, in the time of his father, Constantine the Great. Later, about 387, John Chrysostom mentioned the discovery of three crosses and the identification of the True Cross by its titulus or superscription, which was still attached to the Cross. Chrysostom's account was followed by St. Ambrose in 395, but he added, for the first time, the name of Helena and the discovery of the nails. In the same year, Sulpicius Severus of Gaul supplied another detail, the identification of the True Cross by the resurrection of a dead man. Five years later, Rufinus first mentioned that Bishop Macarius of Jerusalem helped Helena identify the True Cross, but Rufinus speaks only of a dying, elderly woman who was miraculously healed.

Finally, in 595, Gregory of Tours supplied a date for the discovery, 3 May 326. Not surprisingly, this became the feast day for the Discovery of the True Cross in Western liturgy. Gregory of Tours further stated that Helena found the Cross with the aid not of Bishop Macarius, but of a Jew who was later baptized as Quiriacus. This Jew was none other than the Judas who figures in the so-called *Acts of Judas Cyriacus*, an apocryphal account of the finding of the Cross that originated in the early fifth century. According to these *Acts*, which circulated widely in the following centuries, Judas was forced by Helena to help in her search. Although the *Acts* was declared apocryphal, it remained popular, and references to Judas were even included in the readings for the Divine Office for the feast of the Discovery until at least the fifteenth century. This *Acts* is no doubt the main source for the iconography of the right wing of the Triptych.

Helena Interrogates the Jews (3)

According to the *Acts of Judas Cyriacus,* Helena had assembled the learned Jews and asked them to reveal to her the location of the True Cross. In the medallion she is enthroned and demands that the Jews show her the wood (OSTENDITE LIGNUM). Fearing that the discovery of the Cross meant the end of Jewish supremacy, they at first refused to give any information. When threatened by fire, however, they singled out Judas as the one who knew. This explains the inscription "Judas knows" (IUDAS NOVIT), held by one of the Jews. The representation of the fire (IGNIS) is a Mosan contribution to the theme which occurs here for the first time. It is found in at least three other Mosan works (33), but rarely occurs elsewhere. This sudden introduction of the threatening fire may be somehow connected with the forced conversion of Jews in the twelfth century. The old man who nervously touches his beard is identified as Judas. His cane may be a reference to his incredible age, for he was the son of Simon, the brother of St. Stephen (the first martyr), who was still alive at the time of the Crucifixion. The Jews are distinguished by their pointed hats, which are decorated with colored bands, usually of blue, green, or yellow. Although Jews were not required to wear distinctive clothing until the Fourth Lateran Coun-

cil in 1215, the so-called *Judenhut* had made its appearance more than a century earlier.

The earliest depiction of the interrogation, in the early ninth-century Wessobrunn Prayerbook, does not include the fire (34), even though its cycle of eighteen miniatures is one of the most complete and extensive to have survived. Neither does the only other Western example that is earlier than the Stavelot medallion, the late eleventh-century Catalan embroidery in the Gerona Cathedral Museum. The earliest Byzantine example, from the ninth-century Homilies of Gregory Nazianzus, depicts a very regal empress (54). She is enthroned, holds a cross-surmounted globe, has a blue halo, and is protected by two elaborately dressed soldiers. She questions a group of men, but does not look at them. The Helena of the present medallion sits on a more modest throne, is haloed, and is designated as a queen (REGINA) rather than as an empress. Berengosus of Trier likewise called her "Elena Regina."

The composition of the medallion recalls that in the Mosan Psalter Fragment in Berlin (Kupferstichkabinett, 78A6, fol. 7), where Jacob informs his son of the abduction of Dinah. The sons form a group similar to that of the Jews, in which the head of a young son appears between two older bearded brothers shown full-figure. One of the latter strokes his beard. These similarities reflect the interaction between the illuminators and goldsmiths at that time and their use of common models.

Helena Supervises the Finding of the Three Crosses (3)

According to the *Acts of Judas Cyriacus*, Judas did not immediately reveal the location of the Cross and was thrown into a dry well. He remained in the well for seven days without food, before he decided to cooperate. After praying, he led Helena to the place of Calvary. As they approached the spot where the Cross lay hidden, a miraculous fragrance filled the air. Three crosses were found, but they were no longer in their original order,

and the superscription was no longer attached to Christ's Cross.

In the medallion, Helena is now standing and directs the exhumation of the three crosses at Calvary (CALVARIE LOCUS). She points to the third cross, which is labeled as "the hidden wood [the Cross] of the Lord" (LIGNUM DOMINI ABSCONDITUM). Behind Judas, who is about to exhume the third cross, two assistants hold the other crosses, which an inscription identifies as the crosses of the two thieves (PATIBULA DUORUM LATRONUM). Above, the Hand of God and the three rays indicate His miraculous intervention.

The early legends, including the *Acts of Judas Cyriacus*, do not indicate the sequence in which the three crosses were found, though Chrysostom said that the True Cross was known, for it was lying in the middle, and its superscription was still attached. The medallion, thus, seems to differ from the *Acts* in implying that the True Cross was found after those of the thieves. It agrees with Chrysostom in having the distinctive crossbar for the superscription though the letters or words are missing. The True Cross is further distinguished by its translucent enamel, the green color of which identifies it with the Tree of Life. The inscription (LIGNUM DOMINI) and crossbar for the titulus were probably not meant to imply that the True Cross had been found with its titulus. Otherwise the following medallion (5), which depicts the testing of the crosses, would not have been necessary. Rather, these "cues" were meant for the viewer and anticipate the action which is to follow. According to the *Acts*, the True Cross was the last to be tested, and apparently the artist assumed that the crosses were tested in the order in which they were found. Consequently the True Cross was "hidden" to the participants, but the viewer is informed in advance which one it is.

The earliest surviving depiction of Judas digging for the Cross is in the late eighth-century Gellone Sacramentary in Paris; it shows the True Cross in red, flanked by two others in green (53). However, Helena is not present, and the testing scene is not included. The Wesso-

brunn Prayerbook tells the story in five scenes: Judas is thrown into a well (fol. 10), is released from the well and prays (fol. 10ᵛ), is miraculously led to the spot by the fragrance (fol. 12ᵛ), finds a row of three undistinguished crosses (fol. 13), and, finally, removes the three crosses to town for testing (fol. 13ᵛ). In a North Italian drawing from an early ninth-century compendium of Canon Law in Vercelli (Biblioteca Capitolare, Codex CLXV, fol. 2) Judas again finds three crosses in a row but presents only one of them to Helena, so the testing is not illustrated. The Gerona embroidery, of about 1100, shows Judas praying, following the fragrance, and digging for the crosses, but the number of crosses cannot be determined, as the lower portions of the scenes have not survived. The closest compositional analogy, however, is found in the only early Byzantine illustration (54), from the Homilies of Gregory Nazianzus, which generally reflects the earlier Greek sources. Here Helena points to a cross that she has evidently identified from its titulus, so Judas and the other crosses are not included.

The medallion includes one detail not found in earlier Western representations, the orb held by Helena, nor is it present in the other two Helena scenes. That this symbol of worldly or imperial power occurs here stresses the parallel with Constantine's military power in the battle scene opposite.

Helena and the Testing of the True Cross (5)

The authenticity of the True Cross, according to the *Acts of Judas Cyriacus*, could not be immediately determined. However, the corpse of a young man was then being carried to its burial place. Judas, hoping that the True Cross might reveal itself by a miracle, halted the funerary cortege. First one cross and then another was applied to the dead man without result. When the third cross touched the man, he was brought back to life.

In the medallion, a bishop (EPISCOPUS) has successfully applied the True Cross, which is rendered, as before, and is labeled as the wood of the Lord (LIGNUM DOMINI). The crosses of the two thieves, also labeled, have already been tested and are being carried away. The medallion emphasizes the moment of resurrection (MORTUUS SUSCITATUS). The youth sits erect on his bier, actively gesturing with his hands.

In the early ninth-century Wessobrunn Prayerbook (35), the moment of resurrection was not chosen, nor was it selected in a late twelfth- or early thirteenth-century Syriac Lectionary (36) in the British Library, which probably reflects an earlier cycle. Indeed, the earliest surviving depiction of the resurrection dates some three centuries after the Wessobrunn Prayerbook; it occurs in the Gerona embroidery, where the young man is raised by Judas, who is clearly labeled. Similarly a youth is raised in the Beuth-Schinkel Cross in Berlin-Köpenick (33), enamels of which are partly based on our Triptych. The Cross, however, lacks one important detail in the Stavelot medallion, the nameless bishop who applies the Cross. Since major figures are usually specifically identified by inscriptions, the anonymity of the bishop is striking and perhaps intentional. Two identifications are possible. The first and most obvious bishop is Macarius of Jerusalem, who was first mentioned by Rufinus, but he spoke only of the miraculous healing of an elderly woman and not the resurrection of a dead man. Nevertheless, another account, in the *Ecclesiastical History* of Sozomen written some thirty years later, adds the second miracle to the story as well.

The second candidate is Judas himself, for he was converted, took the baptismal name of Cyriacus, and succeeded Macarius as bishop of Jerusalem, according to the *Acts*. However, the bishop is beardless, and Judas is bearded in the other two medallions. It is possible that the absence of beard refers to Judas' conversion, since the beard is sometimes an attribute of the Jew. Other bearded figures and pointed hats are conspicuously absent from this medallion, suggesting that the Jews may have been converted through the discovery. According to the *Acts*, the discovery of the True Cross brought about the end of Jewish supremacy and thus the destruction of the Old

Law. Furthermore, this later Judas was regarded as a second Judas, who, unlike the first, helped to return man to God. For this he was brutally martyred by Julian the Apostate and rewarded with sainthood and a feast day (4 May). Judas thus became a model for conversion, as did Constantine and Helena.

The conversion of Helena, according to the *Acts of Silvester*, resulted from a dispute between twelve leading Jewish doctors and the pope. Silvester won with the help of a miracle, and all the Jews were converted as well. Helena, like the transformed Judas, if indeed the bishop is he, undergoes a parallel elevation. In the first two medallions, where she invokes her imperial powers, she is labeled "ELENA REGINA," but after the True Cross has been identified, she is referred to as "SANCTA ELENA" in the inscription. Moreover, Helena is further differentiated in the sequence of medallions by the color of her halo. These ascend from green at the bottom, to red in the middle, to blue at the top. This hierarchy of colors resembles in part the gradings of feasts found in some twelfth-century Benedictine calendars, where the most important feasts are written in blue. The simple crown she wears in the first two medallions now becomes a double tiara.

The cult of Helena was particularly strong in Trier, not far from Stavelot. It was even claimed that Helena was born there and that its Cathedral had formerly been her palace. It is doubtless these local associations which account for the rather unusual feast of the birth of Helena entered on 15 April in an early tenth-century calendar of Stavelot.

THE CENTER PANEL

The Byzantine Triptychs

Although the wings of the Stavelot Triptych and the cusps framing its center panel have always been regarded as part of the original program, the present arrangement of the two Byzantine triptychs (6–8) has been questioned. Certainly the velvet-covered field surrounding the two triptychs is modern and could not have been part of the original program. It has been suggested that the triptychs were originally supported by angels, similar to those of the nearly contemporary True Cross Reliquary in the church of the Holy Cross at Liège (22). Others have regarded them as nineteenth-century replacements of an earlier program.

In 1973, an examination of the two Byzantine triptychs was undertaken by The Library's conservation department, primarily to determine their connection with the center panel. First, the Crucifixion enamel of the smaller triptych was removed (39), revealing an unexpected cavity in the wooden support; this contained a small pouch, nearly one and a half inches in length, and a rolled-up piece of parchment (41). The pouch, tightly wrapped in red silk thread, held a piece of fine white silk, a small fragment of wood, and some unidentified debris (44). The pouch itself was made from a piece of yellow and brown patterned silk (compound weft twill with paired inner warps) of Byzantine origin, which was probably contemporary with the Byzantine enamels. When the silk was flattened, a design with the head of a griffin could be distinguished (42). A third item, made of copper and resembling the head of a nail was removed from the lower part of the cavity (40). A small pin, which was driven into the head of the nail, actually penetrated through the Crucifixion enamel, below the feet of Christ (39). This pin may have originally been adorned with a pearl, much like the relic of the True Cross in the other small triptych. Because of its position one can imagine that it was regarded as a relic of a Holy Nail.

When the parchment was painstakingly unrolled, an inscription was revealed (43). Unfortunately, it provided neither a date nor mention of Wibald, as did the one in the Alexander Reliquary. Rather, it merely stated that the contents of the pouch came from the Lord's wood (De ligno domini), from the Lord's sepulcher (De sepulchro domini), and from the garment of the blessed Vir-

gin Mary (De vestimento sancte marie virginis). Nevertheless, the inscription is important, since its mid-twelfth-century script confirms that the pouch, its contents, and, by implication, the smaller Byzantine triptych that sealed the cavity belonged to the original plan of the central panel.

These views were further confirmed when the lower frame of the smaller triptych was removed, because it was apparent that the wooden support for the triptych is part of the larger piece of wood supporting the whole central panel (38). If the central panel is original—and there is no reason to doubt this—so also must be the support for the smaller triptych and the triptych itself. The metal frames around the base of the triptych are made of tooled and gilded copper strips, which are similar in design and workmanship to those found on the Mosan wings. Since the other Byzantine triptych was mounted in the same way and on the same wood, it too must have been part of the original program (38).

Although carbon dating of the wooden supports, whose backs are undecorated, has not yet been completed, preliminary results have established that the wood of the center panel is without question earlier than the fifteenth century. The carbon dating of the wood of the wings and the metallurgical examination of the Triptych, undertaken at the Brookhaven National Laboratory, are still in progress and will be the subject of a separate publication.

It is our contention, based in part on the new archaeological evidence, that the two Byzantine reliquary triptychs were originally so placed, that they provided the occasion for the creation of the great Triptych, and that they appear to have influenced the arrangement of the whole. Clearly the representation of Constantine and Helena flanking the Cross (7) in the larger Byzantine triptych determined the placement and general program of the wings. They dictated that the subjects of the enamels on the left wing should relate to Constantine, and the subjects on the right to Helena. As a result of this symmetry, Constantine and Helena are accorded the same number of scenes; this equivalency does not occur in any other early Western cycle.

All fifteen of the Byzantine cloisonné enamels on the two triptychs have been dated to the late eleventh or early twelfth century. Indeed, whatever their date, they must be older than the Triptych itself. The enamels, though not all by the same hand, are stylistically coherent and were probably all made in the same Constantinopolitan workshop, although their original arrangement may have been different. In any case, the mountings for both triptychs are Mosan and contemporary with the wings. The new sculptural relief of their mountings and their placement within a richly scalloped field are wholly Western and in keeping with the rich articulation of surfaces found on the wings.

The Smaller Byzantine Triptych

The smaller of the two triptychs (6–7), the top of which is rounded, contains three cloisonné enamels. Two of them, on the outer wings, depict the Annunciation. On the left wing, an inscription in Greek identifies the archangel Gabriel, who holds a staff. On the right, Mary stands in red shoes on a cushion before a throne and holds a weaver's spindle. The salutory greeting, "Hail, thou that art full of grace," is inscribed in blue letters (Luke I.28).

The third enamel, which forms the center panel, depicts the Crucifixion. The inscriptions flanking the Cross record the words which Christ spoke respectively, to His mother, "Behold thy son," and to John, his disciple, "Behold thy mother" (Luke XIX.26–27). A stream of blood issues from Christ's side. Representations of the sun and the moon as discs flank the small rectangular lacuna at the top of the Cross, where the titulus was originally placed. The metal pin which protrudes below the board on which Christ's feet are nailed (the suppedaneum) has been regarded as a relic of one of the Holy Nails. On the inside of the wings are fragments of fili-

gree work which are framed by a row of mounted glass tessarae.

The Larger Byzantine Triptych

The twelve cloisonné enamels of the larger triptych fall into three groups: those depicting the four Evangelists (6), the four standard Byzantine military saints (7), and Constantine and Helena with two archangels (7).

The four Evangelists, who occupy the outer wings of the triptych, are of extremely high quality, and were conceived as two matching pairs. These conventionalized portraits follow the traditional Byzantine types. At the top, Matthew and John turn slightly toward each other, gesturing with one hand and holding their gospels in jeweled bindings in the other. Both wear tunics and palliums of the same colors and have white hair and beards, though John is partly bald. Both are identified by inscriptions; the latter is also referred to by his special title, "the Theologian." The matching transparent green halos, with cloisons embedded in them, are especially interesting, because they may have prompted the experimentation with transparent enamels pointed out earlier in the Mosan medallions. The portraits themselves appear as roundels because of the cleverly placed triangular cornerpieces. On the bottom, Luke and Mark turn toward each other and, like the upper pair, gesture with one hand while holding their gospels in the other. Here, however, they are depicted with their customary dark hair and beards and have matching blue halos. This matching of halos was evidently observed by the Stavelot enameler, for he also pairs the halos in his bottom medallions, where they are green, and in the top ones, where they are blue.

On the inside of these wings (7) there is a standard group of four Byzantine military saints. Each, shown in court dress, with tunic and chlamys, holds his cross of martyrdom. Again, they form horizontal pairs. At the top, George and Theodore have turquoise halos; at the bottom, Procopius and Demetrius have dark blue ones. The inclusion of these saints on a True Cross reliquary is

highly appropriate, for they all suffered martyrdom because of their devotion to the Cross. Moreover, Procopius, who is placed next to Constantine on the center panel, had a similar vision, for he too saw a cross in the heavens from which the voice of Christ told him, "In this sign conquer." Afterwards, he commissioned a gold cross to be fashioned after the cross of his vision. The enamels of the military saints are framed by a single row of glass tessarae, which match those on the smaller Byzantine triptych. A similar border frames the enamels on the tenth-century Byzantine reliquary of the True Cross that Heinrich von Ülmen brought back from Constantinople in 1207 and is now in the Minster at Limburg-an-der-Lahn.

The last group of enamels (7) are mounted on the center panel, where they flank the relic of the True Cross. All of the figures are identified by inscriptions. On the left is St. Constantine in imperial dress, wearing a ceremonial *loros* (a strip of fabric inlaid with gold and gems), gold armlets (*perikarpia*), and red shoes, a color reserved for the emperor. In his left hand he holds a white scroll tied with a red ribbon; the other is placed on his chest. He wears a crown, and the green color of his halo is the same as that of the archangel Gabriel, whose bust appears above him. Furthermore, the archangel is dressed like the emperor and also wears a *loros*. It has been ingeniously suggested that the depiction of archangels in imperial robes is derived, in a reverse way, from Eusebius' comparison of Constantine to an angel of heaven.

On the right of the Cross is St. Helena, who is slightly shorter than Constantine, but wears a taller crown, as was usual about 1100. In addition to the *loros*, gold armlets, and red shoes, she also wears an elaborate gold collar (*maniakion*) and a shield-shaped object called the *thorakion*. The latter, ornamented with a cross and decorated in the same way as the *loros*, is actually not a shield, but rather a portion of her dress that has been pulled from the back. Helena holds a cross in her left hand and shows the palm of her right hand in a gesture identical to that of the Virgin in the smaller triptych (6). Above her is the

bust of the archangel Michael, but the colors of their halos are not paired, hers being turquoise and Michael's matching those of Gabriel and Constantine.

The archangels point to the relic of the True Cross and to the blue orbs with red crosses which they hold. The arrangement of the archangels is unusual, and their labels may have been mistakenly reversed, for Michael is usually on the left and Gabriel on the right, as in the mid-tenth-century ivory triptych in Paris (51). The wings of the archangels and the decorative cornerpieces again suggest roundels.

The popular Byzantine composition of Helena and Constantine holding or flanking the Cross was regarded as symbolizing their roles in the Legend of the True Cross. It probably goes back to the eighth-century statues of Constantine and Helena holding and presenting the Cross, which were erected on top of the Milion in Constantinople. That sculptural group, in turn, may have been suggested by Eusebius' description of Constantine's *labarum*, which contained portraits of the emperor and his children.

The composition was rarely used in the West, but it appears in one manuscript contemporary with the Stavelot Triptych, the Antiphonary of Saint Peter's, which was illuminated in Salzburg about 1160 (52). There the Byzantine symbolic composition precedes the music for the mass of the Discovery of the True Cross (3 May). Helena and Constantine flank a large cross, which they hold and venerate. The two figures have been significantly transposed, Helena, who alone was canonized by the Western church, occupying the position of greater honor on the left side of the cross. The slightly earlier Salzburg manuscript, the Pericopes of Saint Erentrud in Munich (Staatsbibliothek Clm 15903, fol. 58), places them in their correct Byzantine position even though they accompany the readings for the same Western feast. Both miniatures follow their Byzantine models in showing Constantine and Helena crowned and nimbed. These codices are counterparts to the Stavelot Triptych. Like it, they reveal a receptiveness to Byzantine iconographic formulae, and all pay them homage by incorporating them into a Western context.

This symbolic composition seems to have completely replaced, after the tenth century, the narrative cycle in the East. Indeed, no Byzantine example of a narrative cycle has been recorded beyond that in the Homilies of Gregory Nazianzus (54). The symbolic composition was more appropriate for the Byzantine feast of the Holy Cross (14 September), for it emphasized the elevation and exposure of the Cross. In contrast, the narrative cycle remained predominant in the West. It is a measure of the strength of Byzantine influence in the middle of the twelfth century that an example of the Byzantine symbolic composition in the Stavelot Triptych should have provided the impetus for the narrative cycles on its wings. The Stavelot Triptych is thus a unique document in the history of the iconography of the True Cross for it unites in a single work of art both the Eastern and Western traditions, as they existed in the middle of the twelfth century.

In order to harmonize the Byzantine triptychs with their new surroundings, the Mosan craftsman adopted such features as their gold backgrounds, blue enamel inscriptions, matching halos, and the use of transparent enamel. Even so, features, like the excessive use of yellow in the figures of Constantine and Helena (7), were avoided. The artist preferred colors that would stand out with greater brilliance against the gilt copper background. The choice of silver columns, which frame the enamels, works very well with the color of the vertical accents provided by the mountings for the tesserae found on the inside wings of both Byzantine triptychs.

The Center Panel and Its Frame

Now that it can be accepted that the two Byzantine triptychs were part of the original program, it is possible to reconstruct the areas surrounding them with more confidence. When the modern velvet backing was completely removed (37), a series of hollows in the wooden support

was discovered. These hollows, cut to receive specific gems, are clearly accommodated to the two triptychs. No allowance was made for supporting angels such as those in the True Cross Reliquary in Liège (22); the state of preservation of the cusps indicates that they were never overlapped in any way; and the wings of the small triptychs could not have functioned if such figures were present. Brodsky, however, has suggested the possibility that only the wings of the small triptychs were added later. It is hoped that a scientific examination of the copper used in the hinges of the wings will solve the problem. Beneath some of the original copper nails still embedded in the areas surrounding the two triptychs are the remains of gold foil. Consequently, the spaces surrounding the triptychs must have been covered with solid gold and studded with precious gems. The gold foil would have had a brilliance not found on the wings, where none was used.

Abbot Suger, when describing his great golden crucifix, revealed a desire to achieve similar effects. His agents searched everywhere for precious pearls and gems, and prepared a supply of gold that would be suitable for so important an embellishment. He said that the venerable Cross would be glorified by the admirable beauty of the gems. Through meditation on such many-colored gems he was transported, in an anagogical manner, from this inferior world to a higher one. The gold and precious gems surrounding the triptychs were evidently of greater value than the enamels and gems on the wings, for they were probably removed to provide funds for the monks fleeing Stavelot during the French Revolution. It was for this purpose that the Remaclus Retable was melted down.

The magnificent three-dimensional cusps (8) which frame the central panel were not destroyed, as was the background, because they are made of gilded copper rather than gold. A. A. Barb has noticed that a fairly large number of pre-twelfth-century rectangular altars in France and Spain were ornamented with comparable cusp designs. According to a ninth-century text by Bishop Eldefonso of Spain, it was suggested that these cusps were originally intended to hold the loaves of bread prior to consecration. Barb also found such cusps on semi-circular (*sigma*) and round altars which go back to the early Christian period and antiquity (48). Barb suggested that these semi-circular slabs were patterned after an altar table purporting to be that of the Last Supper and were thus commemorative. In support of his view, he observed that such a table is depicted in the Last Supper on a tenth-century Byzantine paten in the Stoclet Collection in Brussels, in which the prominently placed fish, as the symbol of Christ, suggests the establishment of the Eucharist (47). Barb also reproduced a Last Supper from a German Psalter of about 1225 (46), where the scene is surrounded by cusps strikingly like those on the Stavelot Triptych. Wibald was no stranger to cusp forms, for they frame the Crucifixion (45) of his Sacramentary at Stavelot, a manuscript used by him but not actually made for him.

In the Stavelot Triptych, where the Crucifixion and the Cross relic are both framed by cusps, the same associations can be made. Wibald may well have wondered what kind of table was used at the Last Supper, for he included a relic of it (de mensa Domini) in his Alexander Reliquary (14). It is tempting to speculate that he may have been aware of the tradition that associated the cusped *sigma* altar with the original Last Supper table. In any case, both the Alexander Head and the Triptych would have been exposed at Stavelot on the same day, for the feast of Saint Alexander was also on 3 May.

THEOLOGICAL IMPLICATIONS

The inclusion of the Crucifixion enamel is doubly appropriate, because the Crucifixion constituted the single most important event in the Legend of the True Cross. Without Christ's sacrifice there would have been no redemption; without His victory over death there would have been no resurrection. These thoughts are specifically alluded to in the texts for the mass of the Discovery of the True Cross.

In general, the Divine Office for this day expands the main theme of the mass, and one of its antiphon for Lauds, conveying the same message, is inscribed on the wings (4–5) of the Stavelot Triptych: "Behold the Cross of the Lord: Let adverse parties flee" (ECCE CRUCEM DOMINI: FUGITE PARTES ADVERSE); "The Lion of the Tribe of Judah, of the root of David, has conquered" (VICIT LEO DE TRIBU JUDA, RADIX DAVID). The second part of the antiphon, drawn from the Apocalypse (v.5), refers to Christ's resurrection and victory over death, as is made clear by the commentaries on the passage. The same interpretation is presupposed in a miniature of the Averbode Gospels in Liège, one of the finest of all Mosan manuscripts, where the same passage is written on a scroll held by St. Mark (58). At the bottom of the miniature is a magnificent lion which has breathed life into his cubs, which had been stillborn for three days. According to the mediaeval bestiary, the lion was thus a symbol for Christ, who rose from the dead after he had been dead for three days. The Latin inscription "the mighty lion, who has destroyed the empire of death" is written beneath the miniature.

Although the preceding remarks have dealt specifically with the Crucifixion enamel, they apply equally to the relic of the Cross in the center panel of the other triptych as well. The four pearls that adorn the relic (7), indeed, recall the apocryphal words of the apostle Andrew, which had been cited by Suger in describing his great golden crucifix: "Hail Cross, which art dedicated in the body of Christ and adorned with his members even as with pearls."

The meaning of the Triptych's center panel is perhaps most succinctly summed up in a verse for the office of the Discovery of the True Cross:

Hail Altar, Hail, O Victim, Thee
Decks now thy Passion's Victory
Where, life for sinners, Death endured
And life, by death, for man procured.

An inscription added on the base of the Cross in a mid-

tenth-century Byzantine ivory triptych in Paris (51) conveys a similar sentiment: "He endured the flesh so that man could be saved." Such a triptych, which combines the Crucifixion with representations of Constantine and Helena flanking the Cross, not to mention the roundels on the wings, could easily have served as a model for the Stavelot Triptych. Constantine and Helena, like Mary and John, become new witnesses to the passion of Christ. As one twelfth-century Byzantine poet explained the symbolic composition, Constantine saw the Cross in the sky, while Helena discovered it under the ground; both affirmed its veneration on earth, and thus it is appropriate that both should be united with the Cross in a single image.

Our Mosan artist, in his complementary pairs of medallions on the wings, also expands upon the theme of salvation through the Cross. In the bottom pair, the sleeping Constantine sees the Cross in his mind's eye; the seated Helena demands that the Cross be revealed to her. In the middle pair, physical action is stressed; Constantine defeats Maxentius through the power of the Cross, and Helena, now standing, directs the exhumation of the Cross. In the top and culminating medallions, the divine presence is revealed at Constantine's baptism and the resurrection. This juxtaposition of baptism and resurrection must surely have recalled Paul's Epistle to the Romans (VI.3–8), in which he compared Christian baptism to the death and resurrection of Christ. "Those who have been planted with the likeness of Christ's death [baptism]," he said, "will be planted in the likeness of his resurrection as well." The Epistle was explained by John Chrysostom who identified baptism with the Cross, likened baptismal immersion to Christ's death and entombment, and arising from the water to His resurrection. Baptism, Crucifixion, and Resurrection are linked in yet another way in the Triptych, since the heads of the baptized Constantine and the resurrected youth are perfectly aligned horizontally with the head of the crucified Christ. The antiphon above the wings makes the didactic message clear, as it instructs the viewer to behold or heed

the Cross, for the Lion of Judah has triumphed over death. In the classical gem to the right of the Crucifixion enamel (49–50), a winged goddess of victory bearing her wreath and palm branch seems also to herald this triumph.

SUMMARY

In the investigation of the Stavelot Triptych, it has been shown that it is a mirror reflecting the artistic, liturgical, spiritual, and political milieu of its time. The Triptych, with its Byzantine reliquaries, classical gems, and Mosan enamels, provides a meeting ground for East and West: cloisonné meets champlevé, the Eastern symbolic mode is played against the Western narrative mode, Byzantine hagiography and liturgy are contrasted with their Western counterparts, and Eastern Cross legends are combined with Western ones.

Although various elements in the Triptych seem to reflect Wibald's own varied activities, it must be emphasized that his patronage, though appropriate, is not documented. Likewise the two Byzantine triptychs could have been acquired elsewhere and at a different time, so that the date of the Triptych could be earlier or later than has been suggested here. While serious doubts have been expressed about the attribution of this masterpiece to "G" or Godefroid de Huy, no other name can be suggested. There is, however, one consolation in reducing the Triptych to anonymity. Because the documents remain silent, and there is no encumbering name, the quality and merit of the Stavelot Triptych is forced to speak for itself. That the Stavelot Triptych is a major and influential monument of the Renaissance of the twelfth century is disputed by none.

WILLIAM VOELKLE

DIMENSIONS OF THE TRIPTYCH*

THE STAVELOT TRIPTYCH
Wings open H. 19 1/16 (484) W. 26 (660)
Left wing H. 19 1/16 (484) W. 6 5/16 (161) D. 1 1/8 (28)
Center H. 18 7/8 (480) W. 12 1/2 (318) D. 1 3/4 (45)
Right wing H. 19 1/16 (484) W. 6 3/16 (158) D. 1 1/8 (28)
Medallions DIA. 4 1/4 (108), with beading

THE SMALL BYZANTINE TRIPTYCH
Wings open H. 2 1/2 (63) W. 4 1/2 (115)
Enamels: Crucifixion H. 1 9/16 (40) W. 1 3/8 (35)
Gabriel H. 2 1/4 (57) W. 7/8 (22)
Virgin H. 2 5/16 (58) W. 7/8 (22)

THE LARGE BYZANTINE TRIPTYCH
Wings open H. 4 1/2 (114) W. 7 7/8 (200)
Enamels: Matthew H. 1 7/16 (36) W. 1 7/16 (37)
Luke H. 1 7/16 (36) W. 1 7/16 (37)
John H. 1 7/16 (36) W. 1 7/16 (36)
Mark H. 1 7/16 (36) W. 1 7/16 (36)
George H. 1 13/16 (46) W. 1 1/8 (29)
Procopius H. 1 3/4 (45) W. 1 1/8 (29)
Theodore H. 1 3/4 (45) W. 1 1/8 (29)
Demetrius H. 1 3/4 (44) W. 1 1/8 (29)
Constantine H. 1 5/8 (40) W. 1 (25)
Helena H. 1 5/8 (40) W. 1 (25)
Gabriel H. 1 (25) W. 1 (25)
Michael H. 1 (25) W. 1 (25)

* Measurements in inches and millimeters

25

SELECTIVE BIBLIOGRAPHY

Barb, Alphons A. "Mensa Sacra. The Round Table and the Holy Grail." *Journal of the Warburg and Courtauld Institutes*, XIX, 1956, 40–67.

Brodsky, Joyce. "The Stavelot Triptych: Notes on a Mosan Work." *Gesta*, XI, 1972, 19–33.

Brodsky, Joyce. "Le groupe du triptyque de Stavelot: notes sur un atelier mosan et sur les rapports avec Saint-Denis." *Cahiers de civilization médiévale*, XXI, 1978, 103–120.

Collon-Gevaert, Suzanne; Lejeune, John; and Stiennon, Jacques. *A Treasury of Romanesque Art, Metalwork, Illuminations and Sculpture from the Valley of the Meuse*. London, 1972, 208.

Deshman, Robert. "Otto III and the Warmund Sacramentary. A Study in Political Theology." *Zeitschrift für Kunstgeschichte*, XXXIV, 1971, 1–20.

Falke, Otto von, and Frauberger, Heinrich. *Deutsche Schmelzarbeiten des Mittelalters*. Frankfurt am Main, 1904, 68, 87.

Gauthier, Marie-Madeleine. *Émaux du moyen âge occidental*. Fribourg, 1972, 124–126.

Jakobi, Franz-Josef. *Wibald von Stablo und Corvey (1098–1158). Benediktinischer Abt in der frühen Stauferzeit*. Münster in Westfalen, 1979, 276.

Read, Charles Hercules. "On a Triptych of the Twelfth Century from the Abbey of Stavelot in Belgium." *Archaeologia*, LXII, 1910, 21–30.

Rhein und Maas. Kunst und Kultur 800–1400. Cologne, I, 1972, II, 1973, various references.

Stylianou, Andreas and Judith A. *By This Conquer*. Nicosia, 1971, 44–49 and 1–13 for a survey of Cross legends.

Verdier, Philippe. "Émaux mosans et rheno-mosans dans les collections des États-Unis." *Revue belge d'archéologie et d'histoire de l'art*, XLIV, 1975, 51–57.

Wessel, Klaus. *Byzantine Enamels from the 5th to the 13th Century*. Shannon, 1969, 153–157.

MOSAN ART AND STAVELOT

A BRIEF CATALOGUE

1 TRIPTYCH OF THE TRUE CROSS 22, 67–68
Liège?, ca. 1160
Gilt copper and enamel (550 × 520 mm.)
Liège, Trésor de l'Église Sainte-Croix

This triptych is part of a small group of nearly contemporary works dealing with the theme of the Last Judgment. At the Judgment, according to the *Golden Legend* and other texts, the insignia of Christ's passion will appear. Here two angels, labeled "VERITAS" (Truth) and "JUDICIUM" (Judgment), hold the instruments of the passion, including a relic of the True Cross; above the relic is a small enamel with an angel labeled "MISERICORDIA" (Mercy). In a large niche at the top is the risen Christ, whose victory over His own death gives assurance that the dead will be resurrected; in the corresponding niche at the bottom is a group of haloed monks above whom is inscribed "RESURRECTIO SANCTORUM." On the wings are conventional portraits of the twelve apostles.

2 RELIQUARY IN THE SHAPE OF A GABLE
Maastricht?, ca. 1165
Gilt copper and enamel (560 × 330 mm.)
Brussels, Musées Royaux d'Art et d'Histoire, Inv. no. 1037

This belongs to a set of four gabled reliquaries in Brussels dedicated to the bishops Valentius, Gondolphus, Monolphus, and Candidus. All four reliquaries were housed in the church of St. Servatius in Maastricht, along with a stylistically related shrine of St. Servatius, the patron of Maastricht.

An unidentified bishop, either Valentius or Monolphus, rises from his tomb and looks up at two angels pointing to the crown of the elect. The composition may be compared with that of the Triptych of the True Cross in Liège (**22**).

3 DRAWING OF THE LOST REMACLUS RETABLE OF STAVELOT 10
Stavelot, 1661
Drawing (1050 × 1050 mm.)
Liège, Archives de l'État

The original Retable, which is known only through this drawing, was commissioned by Abbot Wibald of Stavelot, as the dedicatory inscription in the upper left says (HOC OPUS FECIT ABBAS WIBALDUS) and was probably made between 1145 and 1158. All that remains of the Retable, which must have been over nine feet in both height and width, are two superb champlevé enamel roundels (**12–13**) and two short inscriptions (no. 5). The two enamels appear in the drawing flanking the dove of the Holy Spirit, under the gable over the shrine of Remaclus, the end of which depicts Christ flanked by St. Peter and Remaclus. On either side of the shrine are eight rectangular panels with scenes from the life of Remaclus. In the bottom register: (1) the child Remaclus is placed under the care of St. Eligius, (2) King Siegbert hands Remaclus the crozier of the see of Maastricht, (3) St. Trudo is told in a dream by an angel to seek the advice of Remaclus, and (4) Remaclus receives Trudo. In the top register: (5) Siegbert grants Stavelot to Remaclus, (6) the church of Malmédy is built on the site of an altar of Diana, (7) Stavelot is built, and (8) Remaclus is entombed. Above the gable is a bust of Christ from which radiate the four cardinal virtues and the four Evangelists. This group is flanked by angels at the top and below by Enoch and Elijah in Paradise (left) and by Remaclus led to Paradise by an angel (right).

4 FIDES BABTISMUS AND OPERATIO
Brussels, 1978–1979
Gilt copper and enamel (DIA. 145 mm.)
Stavelot, Musée de l'Ancienne Abbaye

These copies, made by a Brussels goldsmith, reproduce the two extant enamels from the Remaclus Retable: one depicts FIDES BABTISMUS, a personification of Faith holding a baptismal font (12); the other shows OPERATIO, probably a personification of *bona opera* or good works, who holds a covered spherical vessel (13). The two enamels appear in the 1661 drawing of the Retable, under the gable over the shrine of Remaclus (no. 3, 10). In style these roundels are close to those on the Stavelot Triptych and were most likely made in the same workshop.

5 TWO INSCRIPTIONS FROM THE REMACLUS RETABLE
Mosan, between 1145 and 1158
Gilt copper and *vernis brun* (12×325 mm.)
Stavelot, Trésor de l'Église Primaire

Like the FIDES and OPERATIO medallions, these inscriptions confirm the remarkable accuracy of the 1661 drawing of the Remaclus Retable (no. 3, 10). Both of them served as captions for scenes from the life of Remaclus, one of which depicted the building of Stavelot (QUO. NEMUS. ERVITUR. STABULAUS. XRO.), and the other, the entombment of Remaclus (TERREA. PARS. FIT. HUMUS. PETIT. ETHERA. SPS. HUIUS.).

6 TWO ANGELS WITH THE TREE OF LIFE 11
Mosan, ca. 1160
Gilt copper and enamel (DIA. 94 mm.)
Huy, Trésor de la Collégiale Notre-Dame

This medallion and perhaps the Charity roundel of the same size formerly in Berlin (Kunstgewerbemuseum) are fragments from an otherwise unknown shrine or reliquary. Here two angels, personifying Mercy (MISERICORDIA) and Truth (VERITAS), as in the Liège Triptych (no. 1, 22), represent the Lord's universal ways (UNIVERSE VIAE DOMINI). The angels flank the Tree of Life (LIGNUM VITAE) and hold a scroll with an inscription based on Apocalypse II.7, "To him that overcometh I will give to eat of the Tree of Life" (QUI VICERIT DABO ILLI EDERE DE LIGNO VITE). The drawing of the angels is extremely close to that in the medallions of the Stavelot Triptych and may be by the same hand.

7 PROCESSIONAL CROSS 63–64
Mosan, ca. 1160
Gilt copper and enamel (445×315 mm.)
Brussels, Musées Royaux d'Art et d'Histoire, Inv. no. 2293

During the second half of the twelfth century, many similar crosses, with or without the corpus of Christ, were produced in the Mosan region. Frequently these included enamels depicting Old Testament subjects that were thought to prefigure the sacrifice of Christ on the Cross. On the arms of this cross are depicted the Offerings of Abel (ABEL) and Cain (CHAIM); and on the shaft, Aaron Marking the Tau Cross on the Forehead of an Israelite (SIMILIS AARON), Moses and the Brazen Serpent (LEX MOYSI), and an Israelite House Marked with the Tau Cross (MACATIO AGNI). The reverse of the cross has five engraved copper plaques with open-work rosettes, which are situated at the extremities of the cross and at its center.

8 BAPTISM OF CHRIST 18
Mosan, ca. 1160
Gilt copper and enamel (102×102 mm.)
New York, The Metropolitan Museum of Art, 17.190.430

This enamel and ten or eleven others of the same size probably come from a single project, but are now scattered in several collections: three others are in the Metropolitan Museum (nos. 9–10, 19–20); four in the Victoria and Albert Museum, London; one in the British Museum, London (17); and two or three in the Louvre, Paris. Although by several hands, they are all similar in style to the Stavelot Triptych and may have been made in the same workshop. While it resembles in general the Baptism on Reiner of Huy's earlier baptismal font in Liège, it is closer in some details to the Baptism (fol. 10) in the Mosan Psalter Fragment in Berlin (no. 19). All three probably depend on a common model, rather than directly on one another.

9 CRUCIFIXION 19
Mosan, ca. 1160
Gilt copper and enamel (102×102 mm.)
New York, The Metropolitan Museum of Art, 17.190.431

Although this enamel plaque belongs to the same group as the Baptism of Christ (no. 8, 18), it differs in rendering the flesh areas

of Christ in full enamel and the details of His face by extremely thin cloisons. If these techniques were directly inspired by the Byzantine Crucifixion on the Stavelot Triptych (39), as Joyce Brodsky has suggested, the likelihood is strengthened that this enamel and, by association, the others of its group were produced in the same workshop as the Triptych.

10 PENTECOST 20
Mosan, ca. 1160
Gilt copper and enamel (102×102 mm.)
New York, The Metropolitan Museum of Art,
 The Cloisters Collection, 65.105

This plaque, part of the same group as the preceding two, exhibits a greater use of transparent enamel, achieving effects similar to those on the Stavelot Triptych. The subject, the Descent of the Holy Spirit on the Apostles fifty days after the resurrection of Christ, is interesting because of its emphasis on St. Peter, who was regarded as a successor to Moses. Indeed, as preserved in the much later Biblia Pauperum, Moses Receiving the Old Law was regarded as an antetype for the Pentecost. In the nearly contemporary Lectionary of St. Trond in the Morgan Library (no. 20, 55), Peter is likewise emphasized and holds his keys.

11 RELIQUARY TRIPTYCH OF THE TRUE CROSS 21
Mosan, ca. 1160
Gilt copper and enamel (292×318 mm.)
New York, Private Collection

This reliquary triptych, like that in Liège (no. 1, 22) has as its main theme the Last Judgment. The angels Truth (VERITAS) and Judgment (IUDICIUM) hold a relic of the True Cross; below Justice (IUSTICIA) holds her scales, which are tempered by Mercy (MISERICORDIA) and Piety (PIETAS) kneeling at her feet. Flanking the head of Justice are two busts representing Almsgiving (ELEMOSINA) and Prayer (ORATIO). Directly below are two groups of heads representing the peoples of the world (OMNES GENTES), for whom this Justice was established. In the niche at the top is Christ, the Son of Man (FILIUS HOMINIS), holding the crown of thorns (CORONA SPINEA) and the cup of vinegar (VAS ACETI). The trumpets of the resurrection are sounded by two angels on the wings, who are designated as the heralds of the world (PRECONES MUNDI), and beneath them the dead rise from their graves (RESURRECTIO MORTUORUM). The outsides of the wings, in *vernis brun*, are decorated with a vine pattern entwining a geometrical lattice.

12 RELIQUARY OF THE TRUE CROSS 65–66
Mosan, ca. 1200
Gilt copper and enamel (575×305 mm.)
Brussels, Musées Royaux d'Art et d'Histoire, Inv. no. 1035

This reliquary consists of a framed rectangle, which is surmounted with a niche containing a bust of Christ, as in the Liège Triptych (no. 1, 22, 67). In the center, a cross with two arms stands on a little hill, from which flow the four rivers of Paradise, and in the corners of the frame are the symbols of the four Evangelists. On the back, inscribed in *vernis brun*, are the names of various saints, including Lambert and Remaclus, whose relics were venerated in the diocese of Liège.

13 ARRAS RELIQUARY
Mosan, ca. 1200
Gilt copper and enamel (H. 360, DIA. of base 145 mm.)
New York, The Pierpont Morgan Library

This is known as the Arras Reliquary, because it belonged to the convent of the Ursuline Order at Arras in the first half of the nineteenth century. It is the earliest preserved reliquary of a type known as an ostensory (from the Latin word *ostendo* meaning to show or display), which reveals its contents through transparent rock crystal. The custom of displaying relics in such ostensories became increasingly popular in the following centuries. Although it is said to have contained the relics of Saints Denis and Ursula in the seventeenth century, its original contents are uncertain and remain a matter of speculation. The style and color of its enamel ornamentation—it has no representations—are unquestionably Mosan.

14 MALMESBURY CIBORIUM
English or Mosan, third quarter of the twelfth century
Gilt copper enamel (H. 200; DIA. 155 mm.)
New York, The Pierpont Morgan Library

The Malmesbury Ciborium, named after the abbey from which it was said to come in the last century, is a receptacle for the eucharistic wafer. Other ciboria of related shape, style, date, technique, and iconography have been localized in England. If so, they were strongly influenced by Mosan art.

The iconographical scheme is typological. Six Old Testament scenes on the bowl are paired with the six New Testament scenes that they prefigure on the cover: Aaron and the Flowering Rod with the Nativity; the Offerings of Cain and Abel with the Presentation in the Temple; the Institution of Circumcision, where the child is also nursed, with the Baptism of Christ (Law of New Grace); Isaac Bearing the Faggots to Abraham for his Sacrifice with Christ Bearing His Cross; Moses and the Brazen Serpent with the Crucifixion; Gaza after Samson's Escape with the Three Marys at the Empty Tomb.

15 LIFE AND MIRACLES OF SAINT REMACLUS, in Latin
Mosan, ca. 1050
Manuscript, 65 leaves (315×240 mm.)
Brussels, Bibliothèque Royale, MS.II,1180

A biography of St. Remaclus, a mid-seventh-century founder of Stavelot, had already been compiled in the ninth century. The present manuscript, from Stavelot and probably the one listed in the 1105 inventory of the abbey's library, is incomplete, but includes important supplementary material on the miracles of the saint during the period from about 850 to the early eleventh century. In its present state the decoration of the manuscript consists of twenty-four fine penwork initials, two of which include a dragon.

16 FLAVIUS JOSEPHUS, *Antiquitates Judaica, Bellum Judaicum*, in Latin
Stavelot, before 1105
Manuscript, 255 leaves (480×320 mm.)
Brussels, Bibliothèque Royale, MS.II,1179

The works of the Jewish historian Josephus were highly regarded during the Middle Ages and most important libraries possessed a copy. This particular manuscript is listed in the 1105 inventory of Stavelot and contains the work of three monks, two of whom are mentioned in the manuscript: Cuno, who prepared the parch-

ment, and Goderanus, a monk of Lobbes and Dean of Stavelot, who wrote the text. It was the same Goderanus who also wrote the text for the Stavelot Bible in the British Library (Add.28106–07). The illumination is limited to two historiated initials, one with an author portrait of Josephus, the other with scenes of the Expulsion of Adam and Eve from Paradise. The artist, who was not mentioned in the manuscript, has been called the Josephus Master.

17 SACRAMENTARY OF WIBALD, in Latin 45
Mosan, first quarter of the twelfth century
Manuscript, 164 leaves (233×165 mm.)
Brussels, Bibliothèque Royale, MS.2034–2035

Although this Sacramentary was not made for Wibald, his ownership of the manuscript is demonstrated by notes added to the calendar which refer to him. The manuscript has not been localized, but stylistic similarities have been observed in the famous Liber Floridus in Ghent (University Library, MS.92), which was completed before 1120, at least ten years before Wibald became abbot of Stavelot (1130–1158). There are only two miniatures in the Sacramentary, a large Crucifixion, which precedes the canon of the mass, and a smaller Christ in Majesty.

18 THE AVERBODE GOSPELS, in Latin 57–58
Mosan, Averbode?, ca. 1160
Manuscript, 171 leaves (277×192 mm.)
Liège, Bibliothèque de l'Université, MS.363C

This richly illuminated Gospels contains some of the finest Mosan miniatures, which are comparable to the best contemporary Mosan enamels and metalwork. The style of the miniatures and some of their borders resemble the work of contemporary enamelers and goldsmiths. As in these other media, the iconography shows a predilection for and fascination with typological programs. For example, the Nativity is linked with the Dew Falling on Gideon's Fleece and Moses before the Burning Bush, both of which are prefigurations or antetypes for the virgin birth. In another miniature St. Mark faces the prophet Ezekiel, who holds a scroll referring to his vision of the four beasts from which the symbols of the Evangelists were derived. Beneath the two is a magnificent lion, which animal, according to the mediaeval bestiary, breathed

life into his cubs on the third day after they were born dead. Consequently the lion was regarded as a type for Christ who, after three days, was also raised from the dead by His Father.

19 MOSAN PSALTER FRAGMENT 24, 27
Mosan, ca. 1160
Manuscript, 10 leaves (250 × 155 mm.)
Berlin, Kupferstichkabinett, 78A6

Although the date and function of this manuscript have been much debated, there can be no doubt that many of its compositions were also used by the leading Mosan goldsmiths, including those in the workshop that made the Stavelot Triptych. The composition depicting Abraham Pursuing the Hostile Kings (27) is so close to that of the Battle of Constantine on the Stavelot Triptych (2) that either one derived from the other, or they must have shared a common model. The manuscript, though it has no text, is usually called a Psalter fragment, but this is uncertain. It has also been suggested that the miniatures formed a model book, as may also two single leaves that were made in the same workshop (Liège, Bibliothèque de l'Université, MS.2613; London, Victoria and Albert Museum, MS.413).

20 ST. TROND LECTIONARY, in Latin 55-56
Mosan, St. Trond?, ca. 1160
Manuscript, 247 leaves (165 × 102 mm.)
New York, The Pierpont Morgan Library, M.883

The miniatures in this Lectionary, the Morgan Library's only Mosan manuscript, are close in style to the miniatures of a *Collationes* of Johannes Cassianus made for the abbey of St. Trond (Liège, Bibliothèque de l'Université, MS.230D). The Lectionary's compositions, like those in the Mosan Psalter Fragment in Berlin (no. 19, 24, 27), were known to goldsmiths. For example, the composition of the Pentecost is similar to that of the Pentecost plaque in the Cloisters (no. 10, 20), and both works share a love

for arched and cusped forms. Other resemblances to metalwork can be observed in the Deposition (56), where the robes of Joseph of Arimathea and Nicodemus have borders that are identical to the hem of Constantine's blanket in the Stavelot Triptych (9), and are similar to the metalwork patterns bordering the center panel of the Triptych (8).

21 VIEW OF THE VILLAGE OF STAVELOT AND ITS ABBEY
Liège, 1743
Engraving (145 × 232 mm.)
New York, The Pierpont Morgan Library

This engraving, based on a drawing by Remacle Leloup. was published in the monumental work by Pierre Lambert de Saumery, *Les délices du pays de Liège* (Liège, III, 1743). The arms of the Abbey of Stavelot are shown on the right, and those of the then Prince-Abbot, Dom Joseph de Nollet (1741-1753), are on the left. Leloup, a prolific topographical artist, was active in Spa and provided 137 of the plates in Saumery.

22 VIEW OF STAVELOT AS IT APPEARED IN THE EIGHTEENTH CENTURY
Stavelot, 1839
Drawing (890 × 1016 mm.)
Stavelot, Musée de l'Ancienne Abbaye

This drawing, which copies an earlier one, contains a detailed and precise list at the bottom of all the buildings that existed in the eighteenth century. The dome atop the abbey tower with its four turrets replaced an earlier steeple which had been destroyed by lightning in 1701. The base of the tower is all that now remains of the large and majestic Romanesque church erected by Abbot Poppon and consecrated in 1040. The arms of the abbey, which include the wolf of St. Remaclus saddled with a pack, are shown at the upper right of the drawing.

THE LEGEND
OF THE TRUE CROSS

A BRIEF CATALOGUE

23 BOOK OF HOURS, with Utrecht calendar, in Dutch
Delft, ca. 1470
Manuscript, 300 leaves (166×115 mm.)
New York, Bernice B. Carton

fol. 38ᵛ: *Crucifixion*, with the two thieves and Mary and John flanking a *tau* cross. (Long Hours of the Holy Cross)

fol. 39: *Moses and the Brazen Serpent*, with Moses, at left, pointing to the serpent on a *tau* cross. On the right, three Israelites marked with a *tau*. (Initial H)

fol. 39: *Fall of Man*, with Adam and Eve flanking the tree with an identical serpent, and holding the fruit. (Medallion in right border)

These three scenes succinctly tell the story of the True Cross, beginning in the border with Adam and Eve taking the forbidden fruit. In the historiated initial is Moses and the Brazen Serpent, regarded as a prefiguration of the Crucifixion, which occupies the full page opposite. According to the Wessobrunn Prayerbook, Adam ate the forbidden fruit at the same time of day (the hour of None) as Christ died on the Cross, completing the analogy between the Fall and Redemption. The analogy applied to the tree as well, for the tree of death became, through Christ's suffering, the Tree of Life. According to the Legend of the True Cross, the wood of the Cross was propagated from the tree that brought about the Fall of Man.

24 BOOK OF HOURS, use of the Augustinian Canons of the Windesheim Chapter, in Latin **62**
Utrecht, ca. 1440, for Catherine of Cleves,
 Duchess of Guelders
Manuscript, 328 pages (192×130 mm.)
New York, The Pierpont Morgan Library, M.917

p. 75: *Death of Adam*. The dying Adam instructs Seth to secure a branch from the Tree of Mercy. Seth, shown a second time, departs with straw hat and staff. Through a small window can be seen a single tree. (Matins, Friday Hours of the Compassion of God)

p. 85: *Seth Receiving a Branch of the Tree of Mercy*, given by the archangel Michael in front of the golden gate of Paradise. Behind the high wall can be seen the tops of two trees. On the left, one of the rivers of Paradise flows through a sluice gate. (Lauds, Friday Hours of the Compassion of God)

p. 91: *Seth Planting the Branch from Paradise in the Mouth of the Dead Adam*, whose corpse, in a white shroud, has been laid out on a grassy hillside. (Prime, Friday Hours of the Compassion of God)

p. 97: *The Tree Growing from Adam's Grave*. At the base of the tree is Adam's skull; parts of his skeleton are visible beneath the slab. Behind the grave are three small creatures, at least one of which gnaws on a bone. In the lower border, the

hand of God stays the sword of Abraham, who was about to sacrifice his son, Isaac, before a flaming altar. (Terce, Friday Hours of the Compassion of God)

p. 101: *Hewing of the Tree.* Solomon, with a retinue of three, touches the tree, in the center of the miniature, with his scepter. On the left side of the tree a carpenter begins to chop it down. (Sext, Friday Hours of the Compassion of God)

p. 105: *Measuring of the Timber.* Solomon and his retinue of two are on the right of the stump of the tree, with the blade of the axe buried in it. On the left, the carpenter measures the finished timber. (None, Friday Hours of the Compassion of God)

p. 109: *Queen of Sheba Recognizing the Wood.* Holding up her long dress, she fords a stream; behind her is the small footbridge she refused to use, since she perceived that Christ would be crucified on it. On the right bank are Solomon and a courtier; on the left bank, two of the queen's attendants, one of whom is a negro. (Vespers, Friday Hours of the Compassion of God)

p. 114: *Pool of Bethesda.* An angel stirs the water of the miraculous pool in which the log floats (John v.2–4). One lame man is being lowered into the water by an attendant, while two others sit or lie nearby. In the lower border Christ washes the feet of Peter. (Compline, Friday Hours of the Compassion of God)

This cycle, which probably began with a now missing *Tree of Knowledge* or *Fall of Man*, is connected with no. 27. The Cleves cycle is reproduced in the facsimile by John Plummer, and thus not all of the details have been described here.

25 LIMOGES BOOK COVER
Limoges, ca. 1200
Gilt copper and enamel (325×210 mm.)
New York, The Pierpont Morgan Library, Enamel Plaque 1

In the late twelfth and early thirteenth century a large group of similar Crucifixion plaques were produced as book covers. In these Mary and John, with angels above them, flank the Cross, which is frequently rendered in green enamel, referring to the Tree of Life. Here, but not in every case, Adam rises from his grave at the foot of the Cross: this detail may be explained by the beliefs that he was buried on Calvary and that the blood of

Christ restored him to life. According to the Legend of the True Cross, either seeds or twigs from the Tree of Paradise were buried with Adam, and from his grave grew the tree that provided the wood for Christ's Cross. Thus the tree whose fruit caused man's fall from grace was also the instrument of his salvation.

26 BREVIARY, in Latin
Utrecht, ca. 1435, for Arnold I of Guelders, husband of
 Catherine of Cleves
Manuscript, 436 leaves (242×165 mm.)
New York, The Pierpont Morgan Library, M.87

fol. 387ᵛ: *Moses and the Brazen Serpent.* On the left Moses points to the Brazen Serpent. Behind him are his followers, while on the right are two men, a group of soldiers, and bones scattered on the ground. In this curious miniature a Crucifixion by the Master of Otto van Moerdrecht was turned into its antetype by the Master of Zweder van Culemborg. Vestiges of the arm of the Cross can be seen in the gold background, and the right-hand group, unchanged, belongs to Crucifixion iconography. (The scene illustrates the Divine Office of the Exaltation of the Cross, on 14 September, which makes reference to Moses and the Brazen Serpent, a fitting prototype for the Exaltation. Indeed, in the modern Breviary the response to the lesson makes the connection clear: "This is the most worthy tree in the midst of Paradise, on which the Author of salvation by His own death overcame death for all.")

27 BOEC VAN DEN HOUTE (Book of the Wood),
in Dutch
Kuilenburg: Johann Veldener, 6 March 1483
Printed book, 34 leaves (quarto)
Brussels, Bibliothèque Royale, A1582

This rare book—only four copies are recorded—contains the most comprehensively illustrated cycle of the history of the True Cross to have survived. Its sixty-four woodcuts are distributed one to a page and each is accompanied by four lines of Dutch verse. The story begins with Adam sending Seth to Paradise for the oil of mercy and ends with the restoration of the True Cross to Jerusalem by Heraclius. The woodcuts, which were made perhaps a generation before the Veldener edition, may have been originally

arranged in pairs or quadruples on a single block, the individual scenes of which were later separated by sawing in order to accommodate them to the quarto format.

One of the woodcuts, depicting Sheba fording a stream, is connected with the same scene in the Hours of Catherine of Cleves, which was made in Utrecht about 1440 (no. 24, **62**). All of the woodcuts have been reproduced in the facsimile by John Ashton.

28 HISTORIEN BIBEL, with some text, in German
Swabia, end of the fourteenth century
Manuscript, 34 leaves (360×280 mm.)
New York, The Pierpont Morgan Library, M.268

fol. 22ᵛ: *Queen of Sheba Reproving Solomon for Using the Holy Wood as a Bridge.* Sheba, with two attendants, is in the middle and points to the bridge on the right. On the left are Solomon and two others. (Preceded by Alexander scenes)

fol. 23: *Pool of Bethesda.* An angel crouches on the wood of the Cross, which floats on the water. On the left a king approaches, followed by a crowd; on the right, and above and below the pool, are cripples, two of whom are carried on the backs of men. (Followed by Joachim scenes)

29 BOOK OF HOURS, Sarum use, in Latin and French
East Anglia, England, second quarter of the fourteenth
 century, for Howisia de Bois
Manuscript, 198 leaves (318×216 mm.)
New York, The Pierpont Morgan Library, M.700

fol. 72: *Dream of Constantine,* who is asleep in bed, wearing his crown, and with his armor neatly hung on a rack. One of the shields has the double-headed eagle of the Holy Roman Empire. In the heavens above are a small gold cross and a bust of Christ blessing. (Initial D, Matins, Hours of the Cross)

fol. 79: *Battle of Constantine,* who is on horseback, wearing his crown and holding a cross-surmounted standard with the double-headed eagle of the empire. With his soldiers, one of whom brandishes a sword, he confronts the pagan cavalry, identified by a red standard with a winged demon. The spearheaded shaft of the latter is broken, as in depictions of Synagogue. (Initial D, Prime, Hours of the Cross)

fol. 80ᵛ: *Helena Interrogating the Jews.* Crowned and enthroned, she questions a group of Jews, including one woman, before a turreted and domed structure in Jerusalem. (Initial D, Terce, Hours of the Cross)

fol. 82: *Helena Supervising the Discovery and Testing of the True Cross.* On the left, Helena, enthroned, crowned, and holding a cross, supervises the exhumation of a green cross by Judas. In the center a bishop touches the bier with the Cross, at the end of which sits a resurrected corpse. On the right, Helena, crowned as before, but now standing, reaches out her hands. (Initial D, Sext, Hours of the Cross)

fol. 83: *Heraclius Denied Entrance to Jerusalem.* He is crowned and wears a blue robe with ermine collar. He approaches on horseback with the Cross and is heralded by three equestrian trumpeters, but is stopped by an angel above the closed gates of Jerusalem. (Initial D, None, Hours of the Cross)

fol. 84ᵛ: *Heraclius Entering Jerusalem.* Still crowned, but now barefoot and without an ermine collar, Heraclius is about to enter the now open gates of Jerusalem with the Cross. (Initial D, Vespers, Hours of the Cross)

fol. 87: *Heraclius Adoring the Cross.* Dressed as at his entry, Heraclius leads a group, including one Jew, in worshiping the Cross, which is displayed in a gabled tabernacle on an altar, with a hanging lamp above. (Initial C, Compline, Hours of the Cross)

30 JACOBUS DE VORAGINE, *Legenda aurea,* in the
French translation of Jean de Vignay
Bruges, ca. 1460, for Jean IV, Sire and Baron d'Auxy
Manuscript, 124 leaves (379×270 mm.)
New York, The Pierpont Morgan Library, M.672

fol. 61: *Silvester Interpreting Constantine's Dream.* Pope Silvester, wearing a papal tiara, stands beside the leprous emperor, who wears a crown and is bedridden. Silvester had been summoned by Constantine as instructed by Saints Peter and Paul, who had appeared to him in a dream. Silvester points to a double portrait of the saints, thereby explaining that the two men in the dream were not gods, as Constantine had thought, but the apostles Peter and Paul. (Legend of Silvester, 31 December)

31 ANONYMOUS IMITATOR OF RUDOLF
VON EMS, Christ-Heere Chronik, in German
Southeastern Bavaria, ca. 1375–1380
Manuscript, 342 leaves (343 × 242 mm.)
New York, The Pierpont Morgan Library, M.769

fol. 321: *Dream of Constantine.* Wearing his crown in bed, the emperor sees a fiery cross in the sky, pointed out by an angel to the right.

fol. 322ᵛ: *Baptism of Constantine.* Pope Silvester baptizes the emperor, while a cleric on the left holds Constantine's crown.

fol. 323: *Constantine Giving Thanks to Pope Silvester,* clasping his hand.

fol. 324: *Silvester Subduing a Dragon.* The pope holds the key of St. Peter.

32 DIRCK VAN DELFT, *De Tafel van den Kersten Ghelove* (Table of the Christian Faith), summer part, in Dutch
Utrecht, ca. 1405–1410
Manuscript, 226 leaves (215 × 153 mm.)
New York, The Pierpont Morgan Library, M.691

fol. 160: *Silvester Disputing with the Jewish Doctors.* The pope wears an enormous tiara and holds a cross-surmounted staff; to his left is Constantine, wearing a crown and holding a scepter; beside him is Helena, also wearing a crown: all are enthroned and holding books. Before them on the floor are seated four Jewish doctors, rendered on a much smaller scale, wearing red pointed hats, and holding books. (Initial D, illustrating a text dealing with Constantine's leprosy, conversion, and baptism and Silvester's debate with the twelve most learned Jewish doctors, which resulted in their conversion)

33 ABRÉGÉ DES HISTOIRES DIVINES, in French
Northeast France, ca. 1300
Manuscript, 114 leaves (212 × 147 mm.)
New York, The Pierpont Morgan Library, M.751

fol. 50ᵛ: *Silvester Disputing with the Twelfth Jewish Doctor,* who caused a bull to be struck dead by whispering the sacred

name into its ear. On the left, the Jews with a live bull; on the right, Silvester.

fol. 51: *Silvester's Miraculous Reviving of the Dead Bull.* By whispering the name of Christ into the ear of the bull Silvester revives him. The bull inclines toward the kneeling Silvester, and the surprised Jews, on the left, are converted.

fol. 51ᵛ: *Adoring the Cross.* The crowned emperor is joined by two others in worshiping a crucifix.

fol. 53: *Baptism of Constantine.* Silvester, holding a book, baptizes the emperor, who wears a crown.

34 MISSAL, in Latin **60**
Weingarten Abbey, Germany, ca. 1200–1232, for
 Abbot Berthold
Manuscript, 165 leaves (293 × 204 mm.)
New York, The Pierpont Morgan Library, M.710

fol. 89: *Helena Interrogating the Jews.* Crowned and seated on a folding chair, she threatens Judas, who has been singled out by the other Jews and pushed in front of her. The words on her scroll (MORS ET VITA APPOSITA SUNT), asking Judas to choose between life (by cooperating) and death, are taken from an antiphon which was drawn directly from the *Acts of Judas Cyriacus* and was sung at the Divine Office of the Invention of the Holy Cross. (Mass for the Invention of the Holy Cross, 3 May)

fol. 114: *Heraclius Killing Chosroes.* Although the actual decapitation is not shown, it is implied by the way Heraclius, sword in hand, confronts the enthroned Chosroes, grasps his hair, and causes his crown to topple. (Mass for the Exaltation of the Holy Cross, 14 September)

35 PRAYERBOOK, in Latin **61**
Milan, ca. 1420, by Michelino da Besozzo
Manuscript, 95 leaves (170 × 120 mm.)
New York, The Pierpont Morgan Library, M.944

fol. 33ᵛ: *Helena Interrogating Judas and the Discovery of the True Cross.* Helena, crowned, with an attendant and a group of soldiers, threatens Judas by pointing to the fire and a small

dry well. In the foreground, two men exhume three crosses, one of which has a blank titulus board attached. (Prayer for the Invention of the Holy Cross, 3 May)

36 GRADUAL, SEQUENTIARY, AND
SACRAMENTARY, in Latin
Weingarten Abbey, Germany, ca. 1225, for
 Hainricus Sacrista
Manuscript, 147 leaves (242×172 mm.)
New York, The Pierpont Morgan Library, M.711

fol. 101ᵛ: *Helena Supervising the Discovery of the True Cross.*
Helena, crowned, haloed, enthroned, and holding a scepter, supervises Judas exhuming the Cross, here of a red color. (Initial D, formed by an acrobat holding a large hoop, Mass for the Invention of the Holy Cross, 3 May)

37 BOOK OF HOURS, Soissons use, in Latin
Paris, ca. 1230
Manuscript, 140 leaves (165×110 mm.)
New York, The Pierpont Morgan Library, M.92

fol. 108: *Baptism of Constantine.* Pope Silvester baptizes the emperor, who wears a crown. (Initial D, collect of the Mass for Silvester, 31 December)

fol. 110: *Testing of the True Cross.* The corpse on a bier has been restored to life by a green Cross applied by a Jew. A king is part of the group on the right; another person stands to the left of the bier. (Initial D, collect of the Mass for the Invention of the Holy Cross, 3 May)

fol. 112ᵛ: *Heraclius Denied Entrance to Jerusalem.* The emperor, wearing a crown and carrying the Cross, is on horseback and stopped by an angel above the closed gates of Jerusalem. (Initial D, collect of the Mass for the Exaltation of the Holy Cross, 14 September)

38 PRAYERBOOK, in Latin
Tours, end of the fifteenth century, probably by
 Jean Poyet, for Anne de Bretagne, Queen of France
Manuscript, 31 leaves (125×80 mm.)
New York, The Pierpont Morgan Library, M.50

fol. 26ᵛ: *Helena Supervising the Testing of the True Cross.* Helena, crowned and haloed, stands in the middleground with Judas, who holds a spade and points to the three crosses on the ground. A resurrected corpse sits on one of the crosses in the foreground, presumably the True Cross, while a group of people in the background are awed by the miracle. (Prayer to St. Helena)

39 BREVIARY, Roman Office for Franciscan use, in Latin
Bruges, ca. 1500, for Eleanor, Queen of Portugal
Manuscript, 590 leaves (240×170 mm.)
New York, The Pierpont Morgan Library, M.52

fol. 4: *Helena Supervising the Testing of the True Cross.* Helena, crowned and haloed, stands in awe: a resurrected corpse sits on the ground next to the True Cross while another cross is being taken away by a man. Behind Helena is a group of bystanders. (Calendar roundel, May)

fol. 6: *Heraclius Entering Jerusalem.* The emperor, crowned, barefoot, and dressed in a white shirt, carries the Cross into the open gates of Jerusalem. In the background, Heraclius, shown again, this time crowned, richly dressed, on horseback, and carrying the Cross, is stopped by an angel above the closed gates of Jerusalem. (Calendar roundel, September)

fol. 398ᵛ: *Testing of the True Cross.* In the center a male corpse sits on one of the three crosses on the ground. On the right stands an elaborately dressed and crowned man, while on the left a more modestly attired man holds his nose, as in scenes of the Resurrection of Lazarus, which this miniature inexplicably resembles. Although women are present in the crowd behind, Helena cannot be distinguished. The miniature is set within a larger surrounding landscape that includes a boating party in the foreground, as in the bas-de-page of fol. 4. On the frame of the opposite folio, on which begins the Divine Office for the Discovery of the Holy Cross on 3 May, gold branches spell out the beginning of the Magnificat antiphon, a text that occurs on the same page (O CRUX SPLENDIDIOR CUNCTIS ASTRIS MUNDIS CELEBRIS—O Cross, more refulgent than all the stars, honored throughout the world).

fol. 501: *Heraclius Entering Jerusalem.* The emperor, crowned, barefoot, and wearing a white shirt, carries the Cross into the open gates of Jerusalem. He is preceded by a liturgical procession and followed by his page, who carries his outer gar-

ments and leads his horse, and the rest of the procession. (Divine Office for the Exaltation of the Holy Cross, 14 September)

40 PRAYERBOOK, in Dutch and Latin
Ghent, ca. 1430, in the style of the Gold Scroll Master
Manuscript, 318 leaves (116×88 mm.)
New York, The Pierpont Morgan Library, M.76

fol. 292v: *Helena and Judas*. As in number 41, Helena is crowned, haloed, and holding the True Cross in a landscape. On the right, Judas, while holding a spade, points to a hole in the ground. (Mass of the Holy Cross)

41 MISSAL, Rome use, in Latin
Ghent, ca. 1430, in the style of the Gold Scroll Master
Manuscript, 196 leaves (328×246 mm.)
New York, The Pierpont Morgan Library, M.374

fol. 125: *Helena and Judas*. As in number 40, Helena is crowned, haloed, and holding the True Cross in a landscape. On the right, Judas, while holding a spade points to the ground. (Initial N, Mass for the Invention of the Holy Cross, 3 May)

42 LETTER TO CHRIST FROM ABGAR V, KING OF EDESSA (13–50 A.D.), preceded by Psalms 91 and 35 and followed by Christ's Reply and the Story of the Holy Image, in Greek, with Arabic version on verso
Constantinople, late fourteenth century
Manuscript roll (93×3377 mm.)
New York, The Pierpont Morgan Library, M.499

First miniature: *Emperor Constantine and Empress Helena*, both crowned and haloed, holding a cross between them. In Byzantium this composition symbolized their roles in the Legend of the True Cross. (Between Psalms 91 and 35)

43 BREVIARY, Roman Office for Franciscan use, in Latin
Paris, ca. 1355, by a follower of Jean Pucelle
Manuscript, 590 leaves (188×125 mm.)
New York, The Pierpont Morgan Library, M.75

fol. 422v: *Helena Adoring the Cross*. The empress and two others kneel before an altar with a gold Cross. To the right a youth emerges from a tomb, a reference to the Testing of the True Cross. (Divine Office for the Invention of the Holy Cross, 3 May)

fol. 495: *Adoration of the Cross*. A group kneels before an altar as on fol. 422v. (Divine Office for the Exaltation of the Holy Cross, 14 September)

44 JACOBUS DE VORAGINE, *Legenda aurea*, in the French translation of Jean de Vignay
Bruges, ca. 1460, for Jean IV, Sire and Baron d'Auxy
Manuscript, 145 leaves (379×270 mm.)
New York, The Pierpont Morgan Library, M.673

fol. 247v: *Helena Holding the Cross and Nails*. She is crowned, haloed, holds the True Cross and four nails, although only three nail holes are indicated on the Cross. She stands before a pagan altar, from which two statues fall. Two men kneel before the Cross, one of whom kisses it. This grisaille miniature is by the Master of Margaret of York. (Legend of the Discovery of the Holy Cross, 3 May)

45 LE LIVRE DES MERVEILLES DU MONDE, in French
France, probably Angers, ca. 1460, by an artist associated with the Master of Jouvenel des Ursins
Manuscript, 129 leaves (285×218 mm.)
New York, The Pierpont Morgan Library, M.461

fol. 18v: *Cyprus*. A corpse lies outside of its tomb; a man opens fruit from the miraculous apple tree, inside of which is inscribed the name of Jesus; pilgrims kneel in a church where the cross of the good thief, Dismas, is miraculously suspended. Apparently the earth ejected the dead there until Helena brought the True Cross.

fol. 53v: *Judea*. On the right are the Jordan river and religious hermits; on the left is the pool of Bethesda, where an angel stirs the water, presumably to cure the man in the pool.

46 BOOK OF HOURS, Rome use, in Latin
Italy, Florence?, third quarter of the fifteenth century,
 for the Bichi family
Manuscript, 174 leaves (102×75 mm.)
New York, The Pierpont Morgan Library, M.311

fol. 151: *Helena*, a half-length portrait with the empress
crowned, haloed, and holding a cross. (Initial P, Divine
Office of the Passion)

47 BREVIARY, Augustinian use, in Latin
Lombardy, perhaps Pavia, ca. 1475
Manuscript, 421 leaves (156×105 mm.)
New York, The Pierpont Morgan Library, M.799

fol. 343ᵛ: *Helena*, a bust-length portrait of the empress
crowned, haloed, and holding a cross, in an initial D; in
the lower border is a bust of Heraclius, crowned and holding
a cross. (Divine Office for the Exaltation of the Holy Cross,
14 September)

48 BOOK OF HOURS, Strasbourg use, in Latin
Bruges, ca. 1515, known as the DaCosta Hours
Manuscript, 388 leaves (172×125 mm.)
New York, The Pierpont Morgan Library, M.399

fol. 330ᵛ: *Helena*, crowned and haloed, holds a large cross
as her attribute. The three-quarter-length portrait, ascribed
to Simon Bening, is seen against a verdant landscape. (Suf-
frage for St. Helena, whose feast is on 18 August)

49 SACRAMENTARY, in Latin **59**
Mont-Saint-Michel, ca. 1060
Manuscript, 184 leaves (286×215 mm.)
New York, The Pierpont Morgan Library, M.641

fol. 155ᵛ: *Heraclius Denied Entrance to Jerusalem; Heraclius En-
tering Jerusalem*. The miniature is divided in two registers. On
top, Heraclius, on horseback, approaches Jerusalem without
the Cross, but is stopped by an angel holding a cross above
the walled-up gate. Below, Heraclius, on foot, carries the
True Cross into Jerusalem, the gates of which are now open.
This miniature is the earliest representation of the Heraclius
story. (Mass for the Exaltation of the Holy Cross, 14 Sep-
tember)

50 LECTIONARY OF THE GOSPELS, in Latin
Padua, 1436, written by Johannes de Monterchio for
 Pietro Donato, Bishop of Padua
Manuscript, 127 leaves (255×180 mm.)
New York, The Pierpont Morgan Library, M.180

fol. 81: *Heraclius Entering Jerusalem*. The emperor, who is
crowned, barefoot, and dressed in white, carries the Cross
toward the open gates of Jerusalem, followed by a reverent
group. In the background, a wooded encampment, perhaps
that of Heraclius, is set against a red sunset sky. (Gospel read-
ing, John XII.31–36, Mass for the Exaltation of the Holy
Cross, 14 September)

51 JACOBUS DE VORAGINE, *Legenda aurea*, in the
French translation of Jean de Vignay
Bruges, ca. 1460, for Jean IV, Sire and Baron d'Auxy
Manuscript, 155 leaves (379×270 mm.)
New York, The Pierpont Morgan Library, M.675

fol. 77: *Heraclius Entering Jerusalem*. Crowned, but barefoot,
and wearing a white shirt, the emperor carries the large gold
Cross over a small bridge leading to the open gates of Jeru-
salem, where he is greeted by a host of angels. One group
of people follows him, while another awaits him inside. This
grisaille miniature is probably by Willem Vrelant. (Legend
of the Exaltation of the Holy Cross, 14 September)

As the Legend was compiled from various sources, many of which are not readily available or easily read, we are including the pertinent passages from the *Legenda aurea* or *Golden Legend* of Jacobus de Voragine. This work, written about 1250, is a hagiographical encyclopedia arranged according to the feasts of the liturgical year, and our substantial excerpts are taken from the feasts of The Invention of the Holy Cross (3 May), of Saint Silvester (or Sylvester, 31 December), and of The Exaltation of the Holy Cross (14 September), in that order. The passages are quoted from the modern English translation by Ryan and Ripperger, through the kind permission of the Arno Press Inc., reprinters of the original 1941 edition (*The Golden Legend of Jacobus de Voragine*, translated and adapted by Granger Ryan and Helmut Ripperger, New York, Arno Press, 1969).

The Invention of the Holy Cross, 3 May

Under the name of the Invention of the Holy Cross, the Church celebrates the anniversary of the day on which the Cross of Our Lord was rediscovered. Before this time, it had been found by Seth, the son of Adam, in the earthly paradise, as we shall learn below; after that, it was found by Solomon on Lebanon, and again by the queen of Saba in the Temple of Solomon; thereafter it was found by the Jews in a fish pond, and today by Saint Helena on the Mount of Calvary. This event took place more than two hundred years after the Resurrection of Christ.

We read in the gospel of Nicodemus that one day when the aged Adam was ailing, his son Seth went to the gate of the Garden of Paradise and asked for a few drops of the oil from the tree of mercy, that he might anoint his father's body and thus repair his health. But the Archangel Michael appeared to him and said: 'Nor by thy tears nor by thy prayers mayest thou obtain the oil of the tree of mercy, for men cannot obtain this oil until five thousand five hundred years have passed,' which is to say, after the Passion of Christ. However, it is believed that only five thousand one hundred and ninety years had passed from the time of Adam to the Passion of Christ. Another chronicle relates that nevertheless the Archangel Michael gave to Seth a branch of the miraculous tree, ordering him to plant it on Mount Libanus. Still another history, from the Greek, which is admittedly apocryphal, adds that this tree was the same that had caused Adam to sin; and that when he gave the branch to Seth, the angel told him that on

the day when this tree should bear fruit, his father would be made whole. And when Seth came back to his house, he found his father already dead. He planted the branch over Adam's grave, and the branch became a mighty tree, which still flourished in Solomon's time.

Solomon, struck by the beauty of the tree, cut it down in order to use it in the erection of the Temple. But no place could be found wherein it could be used: for sometimes it appeared to be too long, and at other times too short, and when the builders tried to cut it to the length desired, they discovered that they had cut off too much. Thereupon they became impatient with the tree, and threw it across a pond, to serve as a bridge. But when the queen of Saba came to Jerusalem to try the wisdom of Solomon with hard questions, she had occasion to cross this pond; and she saw in spirit that the Saviour of the world would one day hang upon this tree. She therefore refused to put her foot upon it, but knelt instead to adore it. The *Scholastic History* says that the queen of Saba saw the miraculous tree in the Temple, and that upon her return to her own country she wrote to Solomon that upon this tree would one day be hanged the man whose death would put an end to the kingdom of the Jews; whereupon Solomon had the tree taken away, and ordered it to be buried deep in the earth. And at the spot where the tree was buried, the pond called Probatica later welled up; so that it was not only the descent of the angel, but also the power of the tree buried in the earth, which caused the motion of the water and the healing of the sick.

And lastly it is told that when the Passion of Christ drew nigh, the wood of the tree floated to the surface of the water, and that the Jews, seeing it, fashioned Our Lord's Cross from it. But on the other hand, tradition holds that the Cross of Christ was fashioned of four different woods, namely the wood of the palm-tree, of the cypress, of the olive, and of the cedar, which accounts for the verse: *Ligna crucis palma, cedrus, cypressus, oliva*, each of these forming one of the four parts of the cross, namely the upright beam, the cross-beam, the tablet placed at the top, and the shaft which supported the base, or else, according to Gregory of Tours, the stand on which Christ's feet rested. It would appear that Saint Paul referred to the four different kinds of wood when he said: 'You may be able to comprehend, with all the saints, what is the breadth, and length, and height, and depth.' Augustine, the great teacher, interprets these words in this fashion: 'The Cross of Christ: the breadth is the crossbeam upon which His arms were

outstretched; the length reaches from the earth to the crossbeam on which His body hung; the height is above the crossbeam, where His head rested; but the depth is under the earth in which the Cross was buried.' But the reader must judge of the truth of the divers legends which we have here set down; for sooth to say, none of them is mentioned in any authentic chronicle or history.

After the Passion of Christ, the precious wood of the Cross remained hidden in the earth for more than two hundred years, and was at last found by Helena, the mother of the Emperor Constantine, in the following circumstances.

At that time an innumerable horde of barbarians was massing on the bank of the Danube, making ready to cross the river, in order to subjugate the entire West. At these tidings, the Emperor Constantine marched forth with his army, and camped on the other bank of the Danube. But when the number of the barbarians continued to increase, and they began to make their way across the river, Constantine was filled with fear at the thought of the battle which he had to undertake. But in the night an angel awoke him, and told him to lift up his head. And Constantine saw in the heavens the image of a cross described in shining light; and above the image was written in letters of gold the legend: 'In this sign shalt thou conquer!' Taking heart at the heavenly vision, he had a wooden cross made, and commanded that it be carried in the van of his army; and then, falling upon the enemy, he cut them to pieces or put them to flight. After this he called together the priests of the various temples, and asked them what god it might be whose sign was a cross. The priests knew not what to respond, until several Christians came, and unfolded to the emperor the mystery of the holy Cross, and the dogma of the Blessed Trinity. And when Constantine heard them, he believed in Christ; and he received baptism at the hands of Pope Eusebius, or, in the opinion of others, from Eusebius the bishop of Caesarea.

But here again we are dealing with a legend which is contradicted by the *Tripartite History*, the *Ecclesiastical History*, the life of Saint Sylvester, and the chronicle of the popes. Another tradition indeed declares that the Constantine of this story is not the great emperor who was converted by Pope Saint Sylvester, but another Constantine, his father. And this tradition adds that at his father's death, Constantine recalled the victory which the deceased ruler had owed to the power of the holy Cross, and sent his mother Helena to Jerusalem to search for this miraculous Cross.

The *Ecclesiastical History* gives a different account of the victory of Constantine. It tells us that the battle took place near the Pontus Albinus, where Constantine encountered Maxentius, who was attempting to invade the Roman Empire. And when the care-laden emperor raised his eyes to Heaven to plead for succour, he saw in the eastern sky the gleaming sign of the cross, surrounded by angels who said to him: 'Constantine, in this sign shalt thou conquer!' And as Constantine was wondering what this meant, Christ appeared to him during the night, with the same sign, and ordered him to have an image made of it, which would aid him in the battle. The emperor, now assured of victory, made the sign of the cross upon his forehead, and took a gold cross in his hand. Then he prayed to God that the hand that had held the sign of the cross might never be stained with Roman blood. And Maxentius, when he was about to cross the river, forgot that he had caused the bridges to be undermined in order to draw Constantine to destruction; and he started to pass over a bridge which had been sapped, and was drowned in the river. Then Constantine was acclaimed emperor without opposition. And another chronicle, which is of sufficient authority, adds that even then he delayed his conversion until the day when, after Saint Peter and Saint Paul appeared to him in a vision, he was healed of his leprosy, and was baptized by Pope Sylvester. Furthermore Saint Ambrose, in his letter on Theodosius, and the *Tripartite History* affirm that even then he put off his baptism, in order that he might be baptized in the waters of the Jordan. And this the chronicle of Saint Jerome likewise tells us.

However all this may be, it was Helena, the mother of Constantine, who led the search which ended in the Invention of the Holy Cross. Some say that this Helena was an inn-servant whom Constantine's father married for her beauty. Others declare that she was the only daughter of Coel, the king of the Britons, and that Constantine's father took her to wife when he went to Britain, and thus became master of the island at the death of Coel. This is also maintained by the Britons, albeit another account states that Helena came from Trier. When she came to Jerusalem, Helena summoned before her all the learned Jews of the land. And these were alarmed, and said to one another: 'For what cause does the queen summon us?' Then one of their number, named Judas, said: 'I know that she wishes to learn from us where the wood of the Cross upon which Jesus was crucified is to be found. Now here is what my grandsire Zacheus told to my father Simon, who repeated it to me when he lay dying: "My son, whensoever thou shalt be questioned about the cross of Jesus, do not fail to make known where it is, else thou shalt endure torments without number. And yet that day shall be the end of the kingdom of the Jews, and thenceforth they shall reign who adore the Cross, for verily the man who was crucified was the Son of God!" And I said to my father: "Father, if our forefathers knew that Jesus was the Son of God, wherefore did they crucify Him?" And my father replied: "God knows that my father Zacheus never lent his approval to what they did. It was the Pharisees who crucified Jesus, because He denounced their vices. And Jesus rose from the

dead on the third day, and ascended to Heaven in the sight of His disciples. And my uncle Stephen believed in Him, wherefore the Jews, in their rage, stoned him. Beware then, my son, never to blaspheme against Jesus or His disciples!" ' However, it does not seem credible to us that the father of this Judas could have been alive at the time of the Passion of Christ, for from his day to the time of Helena two hundred and seventy years had passed, unless, on the other hand, men lived longer in those days than in our time. Thus spake Judas, and the Jews said to him: 'Never have we heard the like of this!' But when they came before the queen, and she asked them in what place Jesus had been crucified, all refused to make it known to her; and she therefore ordered them all to be cast into the fire. Then the Jews, affrighted, pointed out Judas to her, saying: 'Princess, this man is the son of a prophet, and knows all things better than we; he will reveal to thee all that thou desirest to know.' Then the queen dismissed all save Judas, to whom she said: 'Choose between life and death! If thou wilt live, show me the place which is called Golgotha, and tell me where I shall discover the Cross of Christ!' Judas made answer: 'How should I know this, since two hundred years have passed since then, and I was not even born?' But the queen retorted: 'I swear to thee by the Crucified that I shall let thee die of hunger, if thou refusest to tell me the truth!' And thereupon she had Judas thrown into a dry well, and ordered that no food was to be given to him.

On the seventh day, Judas, weak from hunger, asked to be drawn from the well, and promised to reveal the whereabouts of the Cross. And when he came to the place where it lay hidden, he smelled in the air a delightful aroma of spices; and overcome with astonishment, he exclaimed: 'In truth, O Lord, Thou art the Saviour of the world!'

Now at that place there stood a temple of Venus, which had been raised by the Emperor Hadrian, so that whoever should come to adore Christ would appear to adore Venus at the same time. And for this reason the Christians had ceased to visit the place. But Helena had the temple torn down; whereupon Judas himself started to dig into the earth, and twenty feet beneath the surface he found three crosses, which he at once caused to be carried to the queen.

It remained only to distinguish the one to which Christ had been nailed from those of the thieves. All three were set up in an open space; and Judas, seeing the corpse of a young man being borne to the tomb, halted the cortege, and laid first one, then another of the crosses upon the body. But the corpse did not move. Then Judas laid the third cross upon it; and instantly the dead man came to life.

But the *Ecclesiastical History* relates that it was Macarius, the bishop of Jerusalem, who determined which was the true cross, by using it to revive a noble lady who was near to death.

Saint Ambrose declares that Macarius recognized the Cross by the inscription which Pilate had long ago affixed to it.

When this had occurred, the Devil cried out aloud: 'O Judas, what hast thou done? Thou hast acted quite differently from my Judas. At my behest he betrayed Christ, and thou, against my wishes, hast revealed His Cross. He won over many souls to me, and through thee I shall once more lose them. Through him I was given power over many, and thou wouldst drive me from my kingdom. But I say unto thee: I shall revenge myself, and will raise up a prince against thee who has fallen from his belief in the Crucified, and he will force thee to deny Christ amidst much suffering.' Thereby he meant Julian the Apostate who, after Judas had been made bishop of Jerusalem, tortured him and brought him to martyrdom. But when Judas heard the crying and shouting of the Devil, he was not afraid, but cursed him without fear, saying: 'May Christ damn thee to the depths of everlasting fire!'

Judas was then baptized, took the name of Cyriacus, and was made bishop of Jerusalem at the death of Macarius. And Saint Helena, wishing to have the nails which had pierced Jesus, prayed the bishop to seek them. Cyriacus again betook himself to Golgotha, and began to pray; and at once the nails came into view, shining like gold out of the earth, and he made haste to carry them to the queen. And she, falling to her knees and bowing her head, adored them piously.

She brought back to her son Constantine a part of the Cross, leaving the other part in the place where she had found it. She also gave her son the nails, which, according to Gregory of Tours, were four in number. Two of the nails were placed in the bridle which Constantine used in war; a third was set in the statue of Constantine which overlooked the city of Rome. The fourth Helena herself threw into the Adriatic Sea, which until that time had been a perilous whirlpool for mariners. And she it was who ordained that every year the anniversary of the Invention of the Holy Cross should be celebrated with all solemnity.

The holy bishop Cyriacus was later put to death by Julian the Apostate, who sought to destroy the sign of the cross wherever it was found. Before Julian set out to the war against the Persians, he demanded that Cyriacus offer sacrifice to the idols; and when the bishop refused, he ordered his right hand to be cut off, saying: 'That hand has written much that has led the people away from the worship of the gods!' But Cyriacus answered: 'Mad dog, thou dost me a great service; for this hand has been a scandal to me, since in the past it wrote many letters to the synagogues to turn the Jews away from the worship of Christ!' Then Julian had

molten lead poured into the bishop's mouth, and caused him to be laid upon an iron bed, and burning coals to be thrown upon him, together with salt and fat. But through all this Cyriacus remained unmoved. Then Julian said to him: 'If thou wilt not sacrifice to the gods, at least declare that thou art not a Christian!' At the saint's refusal, he was thrown into a pit of venomous reptiles; but the serpents perished at once, and the bishop was unscathed. Then he was thrown into a cauldron of boiling oil; and at the moment when he entered it, he entreated God to grant him the second baptism of martyrdom. At this Julian, carried away with anger, ordered the executioners to run him through the breast with swords. And in this manner the holy bishop breathed forth his soul to God. . . .

Saint Sylvester, 31 December

. . . At that time Constantine was emperor and began to persecute the Christians; and Sylvester left Rome and retired with his clergy to a nearby mountain. But it came about that Constantine himself, as a punishment for his persecution, was stricken with an incurable leprosy. The priests of the idols then counselled him to have three thousand children slaughtered at the gates of the city, and to bathe in their warm blood. But when he arrived at the place where the children were gathered, Constantine saw their mothers running toward him, their hair dishevelled, weeping and lamenting. Then, with tears streaming down his cheeks, he stopped his chariot, and standing erect, he said: 'Counts, knights, and common folk here present, hear ye! The dignity of the Roman people is born of the pity which has always ruled our way of life; and of old this pity caused it to be decreed that anyone who slew a child in war, should be put to death. But what cruelty would it be, if we wrought upon our own children that which we do not allow to be done even to the children of our enemies? Of what use would it be to have conquered the barbarians, if we allowed ourselves to be conquered by our own brutality? Therefore, in the present circumstance, let pity rule! It is better that I die, and spare the life of these innocents, than that I preserve, by their death, a life stained with cruelty!' And he ordered that the children be returned to their mothers and sent home with gifts; in such wise that the mothers, who had come forth weeping in anguish, went to their homes weeping for joy.

The emperor shut himself up in his palace, resigning himself to die of his malady. But the following night Saint Peter and Saint Paul appeared to him and said: 'Because thou hast refused to shed innocent blood, Our Lord Jesus Christ has sent us here to show thee a way to recover thy health! Summon before thee Sylvester the bishop, who is in hiding on Mount Soracte. He will point out a spring wherein thou art to immerse thyself three times, and thou shalt be cured of thy leprosy. But in return, thou art to destroy the temples of the idols, and to reopen the churches of the Christ; and thou thyself art to be His servant henceforth!' At once, Constantine, awakening, sent a company in search of Sylvester.

And Sylvester, seeing this company approaching, thought that he was called to the palm of martyrdom. He therefore came forward courageously, after recommending himself to God, and delivering a final exhortation to his companions. And Constantine said to him: 'Be thou welcome! We are overjoyed at thy coming!' And he related his whole dream. Thereafter he asked him who the two gods were who had appeared to him: and Sylvester answered that they were not gods, but apostles of Christ. Then he ordered the portraits of the apostles to be brought in, and Constantine immediately recognized Saint Peter and Saint Paul. Sylvester then received him as a catechumen, imposed a seven days fast upon him, and prescribed that he should throw open all the prisons. And when Constantine had descended into the waters of baptism, a great light surrounded him, and he emerged cleansed of the leprosy, and said that he had seen Christ in Heaven. . . .

The Empress Helena, mother of Constantine, was at that time in Bethany: and when she heard of his conversion, she wrote to praise him for having renounced the worship of idols, but also to reproach him sharply because, instead of believing in the God of the Jews, he had now adored a crucified man as God. The emperor responded that she should bring the chief Jewish doctors with her to Rome, adding that he would confront them with the Christian doctors, in order that their discussion might bring out the truth in matters of belief. Helena therefore brought back with her one hundred and forty-one Jewish doctors, of whom twelve shone especially for their learning and their eloquence. . . .

Then Zambri, the twelfth doctor, beside himself, cried out: 'I am taken aback that you, who are such wise judges, should put faith in these quibblings, and should imagine that the omnipotence of God can be measured by human reason. Let us have done with words, and come to deeds! They are fools who adore the Crucified, whereas the Name of God is so mighty that no creature can bear to hear it! And to prove to you that what I say is true, let a wild bull be led hither: and when he shall hear the sacred Name, he shall die on the instant!' And Sylvester said to him: 'How is it, then, that thou thyself hast heard this Name and hast not died?' And Zambri replied: 'It is not fitting that thou, an enemy of the Jews, shouldst know this mystery!' And they led in a wild bull, which a hundred brawny men were hard pressed to hold; and as soon as Zambri had pronounced a name in his ear, the beast was seen to bellow, turn back his eyes, and fall dead.

Whereupon all the Jews began to applaud their champion noisily, and to insult Sylvester. But the latter said: 'The name which this doctor has pronounced is not the Name of God, but that of the foulest of demons; for my God, Jesus Christ, not only does not kill the living, but gives life to the dead. To be able to kill and unable to restore life, befits lions, serpents, and other wild beasts. If then this man wishes to prove to me that he has not pronounced the name of a demon, let him bring back to life that which he has killed! For God has written: "I will kill and I will make to live!"' And when the judges adjured Zambri to revive the bull, he said: 'Let Sylvester revive him, in the name of Jesus the Galilean, and we shall all believe in Him!' And all the Jews made the same promise. Then Sylvester, after a prayer, bent down to the ear of the dead bull, and said: 'O Name of malediction and death, go out of this beast by order of the Lord Jesus, in Whose Name I say: Bull, arise, and go back to thy herd in peace!' and at once the bull arose and went off gently and piously. And then the empress, the Jews, the judges, and all those who witnessed the miracle, were converted to the Christian faith.

Some days later, the priests of the idols came to Constantine and said: 'Holy Emperor, there is a dragon in a cave, and since thou didst receive the faith of Christ, this dragon daily slays more than three hundred men with his breath!' The emperor reported the matter to Sylvester, who answered: 'By the power of Christ, I shall render this dragon harmless!' And the priests promised that if he did this, they would be converted to Christ. Then Sylvester retired to pray. And the Holy Ghost appeared to him and said: 'Go down without fear into the dragon's pit, taking two of thy priests with thee; and when thou standest before him, say these words to him: "The Lord Jesus, born of a Virgin, crucified and buried, then risen from the dead and seated at the right hand of His Father, shall one day come to judge the living and the dead; and thou, Satan, await His coming in this place!" Thereupon thou shalt bind his maw with a cord, which thou shalt seal with a ring bearing the mark of the cross. And thereafter all three of you shall come home to Me, to eat of the bread which I have prepared for you!'

Sylvester, with two priests, went down into the pit, by one hundred and fifty steps, carrying two lanterns. He addressed the dragon with the words of the Holy Spirit, then bound his jaws, which hissed with rage, and sealed them as he had been told to do. And coming out of the pit, he found two magicians, who had followed him to see if he dared to confront the dragon. These two lay almost lifeless on the ground, overcome by the pestilent breath of the monster. The saint revived them, and led them away completely restored; and straightway they were converted, and a great multitude with them. Thus were the Romans de-livered from a twofold death, namely from their pagan belief and from the poison of the dragon.

At last, the blessed Sylvester, feeling the approach of death, gave three monitions to his clergy. He warned them to love each other, to govern their churches diligently, and to guard their flocks from the teeth of the wolves. And that done, he fell asleep happily in the Lord, in the year of grace 320.

The Exaltation of the Holy Cross, 14 September

This feast is called the Exaltation of the Holy Cross, because on this day the faith and the Holy Cross were exalted exceedingly....

The Exaltation of the Holy Cross is solemnly celebrated by the Church, because on that day the Christian faith was exalted to a surpassing degree. In the year of the Lord 615, God suffered his people to be scourged by the cruelty of the pagans. Chosroës, King of the Persians, subjected all the kingdoms of the earth to the yoke of his rule. Yet, when he came to Jerusalem, he withdrew in terror from the Lord's Sepulchre, taking with him, however, the part of the Holy Cross which Saint Helena had left there. Then, as he wished to be adored as a god by all, he built a tower of gold and silver, studded with shining gems, and placed upon it the images of the sun and the moon and the stars. By means of slender and hidden pipes, he caused water to shower down from the height of the tower, as God makes the rain to fall; and in a cavern beneath the earth he had horses running in a circle and dragging chariots, in such wise that they seemed to shake the tower, and made noise like thunder. Then, handing over his kingdom to his son, the profane king seated himself in this fane, and placed the Lord's Cross at his side, demanding that all salute him as God. Moreover, we read in the book of the *Mitral Office* that Chosroës, seating himself upon the throne as the Father, set the wood of the Cross at his right side, in the Son's stead, and a cock at his left side as the Holy Ghost, and commanded that he be called God the Father.

Thereupon the Emperor Heraclius gathered a mighty host, and advanced to the banks of the Danube to meet the son of Chosroës. Then it was agreed between the princes that they would fight alone in the middle of a bridge which spanned the river, and that whoever emerged the victor would take over the other's empire, without damage to either army. And the decree went forth that whosoever dared to come to the aid of his prince would have his arms and legs cut off, and be thrown into the river. Then Heraclius offered himself wholly to God, and commended himself to the holy Cross with all possible devotion. And when the twain joined combat, God gave the victory to Heraclius, and he sub-

jugated the hostile host to his rule, so that Chosroës' entire people accepted the Christian faith, and received holy baptism.

Chosroës, however, knew not the issue of the war, because, since all hated him, no one made it known to him. But Heraclius came to him, and finding him seated upon his golden throne, said to him: 'Because, in thy foolish way, thou hast honoured the wood of the holy Cross, I shall spare thy life and leave thee thy kingdom, taking but a few hostages, on the condition that thou accept the Christian faith and baptism; but if thou refuse to fulfil this, I shall smite thee with my sword and cut off thy head!' But the king would not consent, and Heraclius drew his sword and beheaded him, but commanded him to be buried with kingly honours. Then he took the king's son, a boy of ten years whom he found with him, and had him baptized, and he himself lifted him from the sacred font, and bequeathed to him his father's realm. He also destroyed the tower, distributing the silver thereof to his army as booty, and reserving the gold and the jewels for the rebuilding of the churches which the tyrant had demolished.

Thereafter he carried the holy Cross back to Jerusalem. When he descended the Mount of Olives, riding upon his royal charger and arrayed in imperial splendour, and was about to enter by the gate through which Christ had gone to His Passion, suddenly the stones of the gate fell down and formed an unbroken wall against him. Then, to the astonishment of all, an angel of the Lord appeared over the gate, holding a cross in his hands, and said: 'When the King of Heaven, coming up to His Passion, entered in by this gate, He came not in royal state, but riding upon a lowly ass; and thus He left an ensample of humility to His worshippers!' With these words the angel departed. Then the king burst into tears, took off his shoes, and stripped himself to his shirt, took up the Cross of the Lord and humbly carried it to the gate. Instantly the hardness of the stones felt the power of God go through them, and the gate lifted itself aloft, and left free passage to those who sought to enter. And a most sweet fragrance, which, at the day and hour wherein the Cross was taken from the tower of Chosroës, had crossed the long reaches of land between and spread from Persia to Jerusalem, now returned, and refreshed all with its perfume. Then the most pious king burst forth with praises of the Cross: 'Hail, O Cross, more splendid than all stars, illustrious before the world, most lovely unto men, holier than all things else, thou alone wert worthy to bear the price of the world! O sweet tree, sweet are the nails, sweet the sword, sweet the spear, and sweet the burden thou bearest! Save the multitude gathered today in praise of thee, and marked with thy banner!' . . .

In some chronicles, however, these deeds are otherwise narrated. It is said that when Chosroës was invading all the kingdoms round about, and captured Jerusalem, taking the Patriarch Zachary and the wood of the Cross, Heraclius sought to make peace with him; but he swore that he would not make peace with the Romans until they had abjured the Cross and adored the sun. Then Heraclius, armed with zeal, brought up his army against Chosroës, routed the Persians in many battles, and forced their king to flee to Ctesiphon. At length Chosroës, being stricken with dysentery, wished to confer the crown on his son Medasas. When his eldest son Syrois heard of this, he made a pact with Heraclius, pursued his father and the nobles, and threw them into prison; and after feeding his father with the bread of tribulation and the water of sorrow, he ordered him to be put to death with arrows. Thereafter he despatched all the prisoners to Heraclius, with the patriarch and the wood of the Cross: and Heraclius carried the precious wood to Jerusalem, and later transferred it to Constantinople. Thus we read in many chronicles. . . .

SELECTIVE BIBLIOGRAPHY

Ashton, John. *The Legendary History of the Cross. A Series of Sixty-four Woodcuts from a Dutch Book Published by Veldener, A.D. 1483*. London, 1887.

Jacobus de Voragine, *The Golden Legend*. Translated and adapted by Granger Ryan and Helmut Ripperger. 2 vols. London, 1941 (reprinted in one vol. by Arno Press Inc., New York, 1969)

Morris, Richard (ed.). *Legends of the Holy Rood*. Early English Text Society, vol. 46. London, 1871.

Napier, Arthur S. (ed.). *History of the Holy Rood-Tree*. Early English Text Society, vol. 103. London, 1894.

Plummer, John. *The Hours of Catherine of Cleves*. New York, 1966.

Quinn, Esther Casier. *The Quest of Seth for the Oil of Life*. Chicago, 1962 (with extensive bibliography, 165–187).

Seymour, William Wood. *The Cross in Tradition, History, and Art*. New York, 1898.

Wiegel, Karl Adolf. *Die Darstellungen der Kreuzauffindung bis zu Piero della Francesca*. Cologne, 1973.

ILLUSTRATIONS

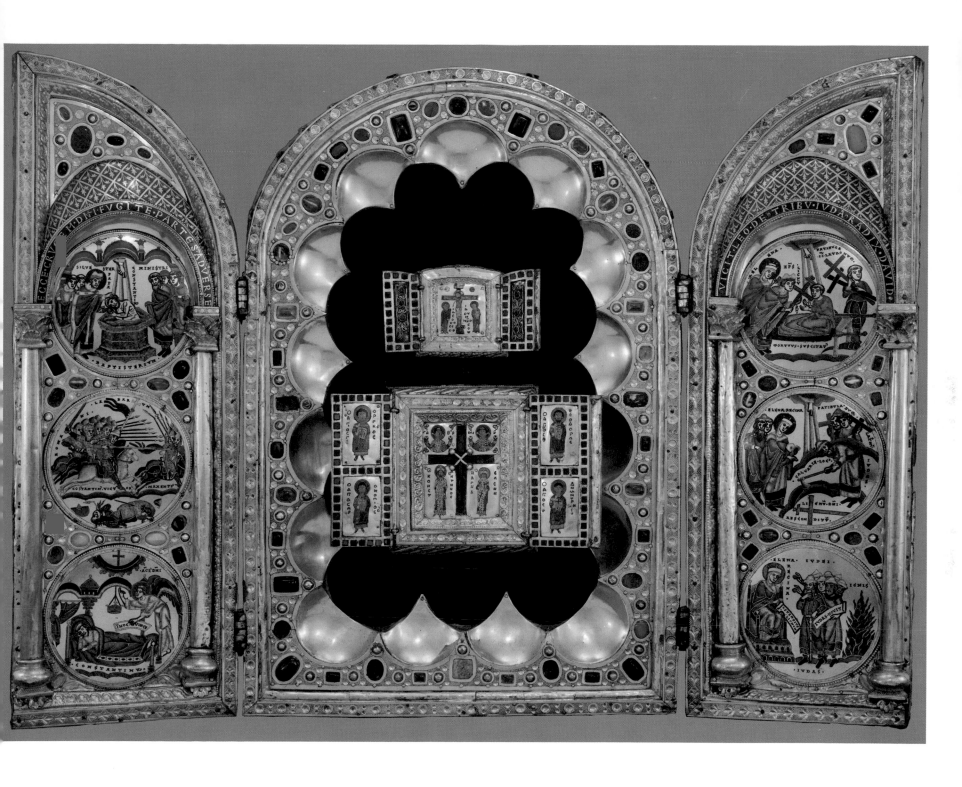

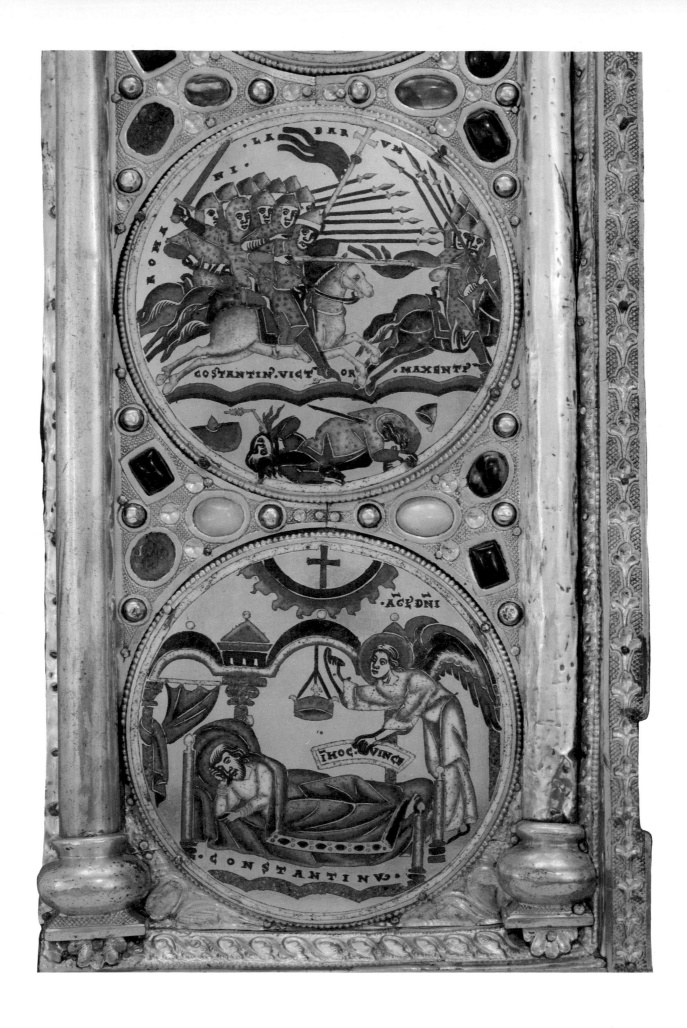

2

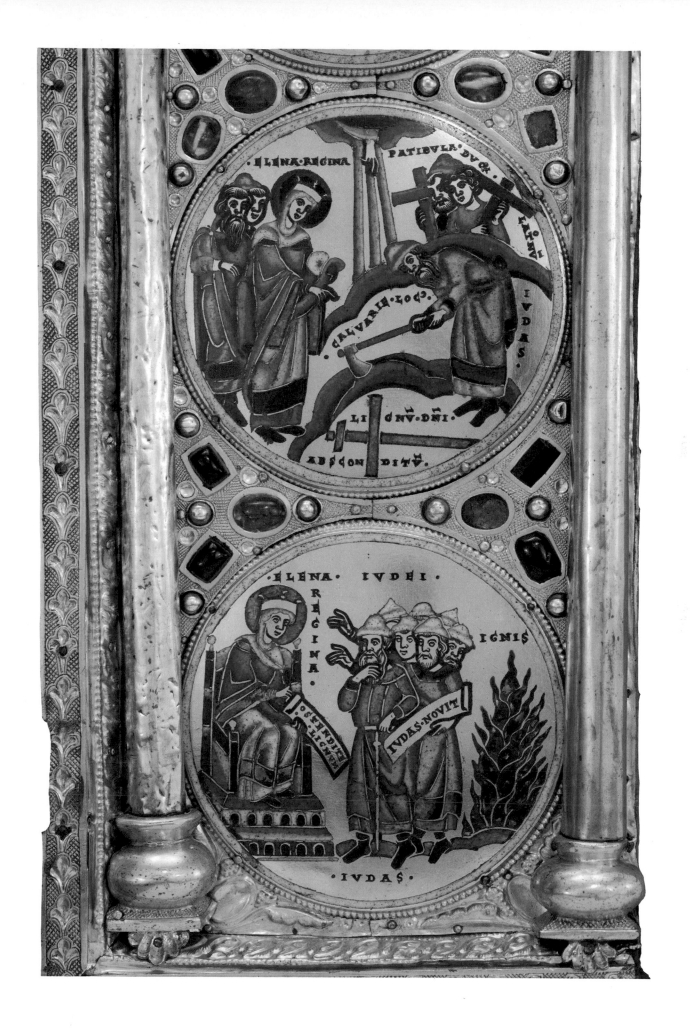

·ELENA·REGINA PATIBVLA·DVC

CALVARIE·LOCO

LI ·GNV·DÑI·

ABSCON DITV

IVDAS·

·ELENA· IVDEI

REGINA· IGNIS

IVDAS·NOVIT

·IVDAS·

3

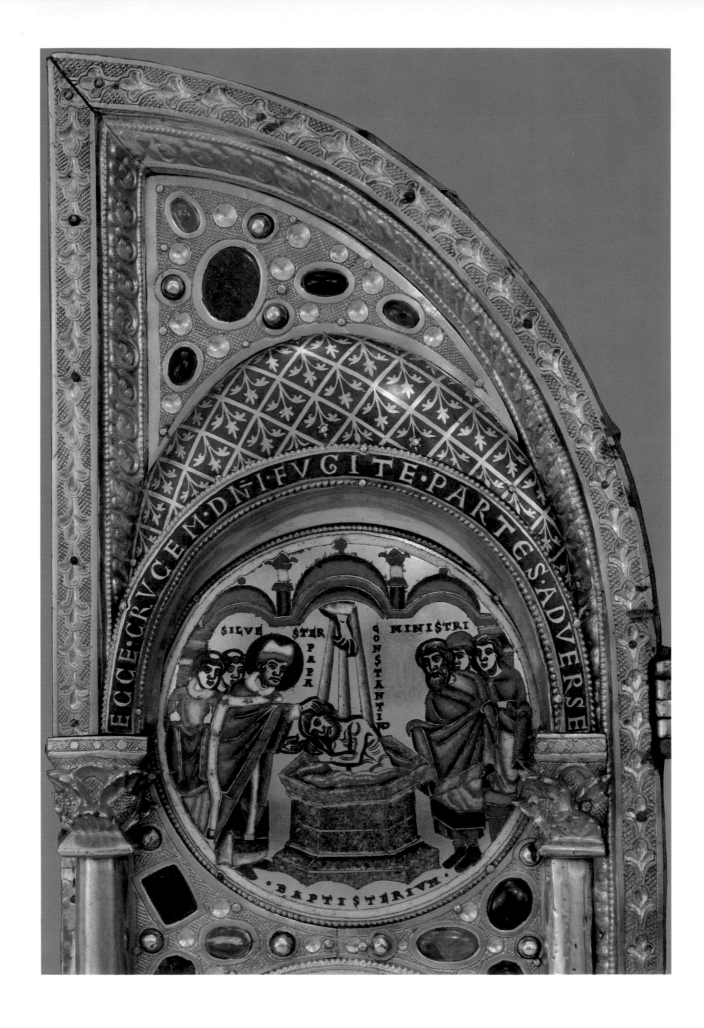

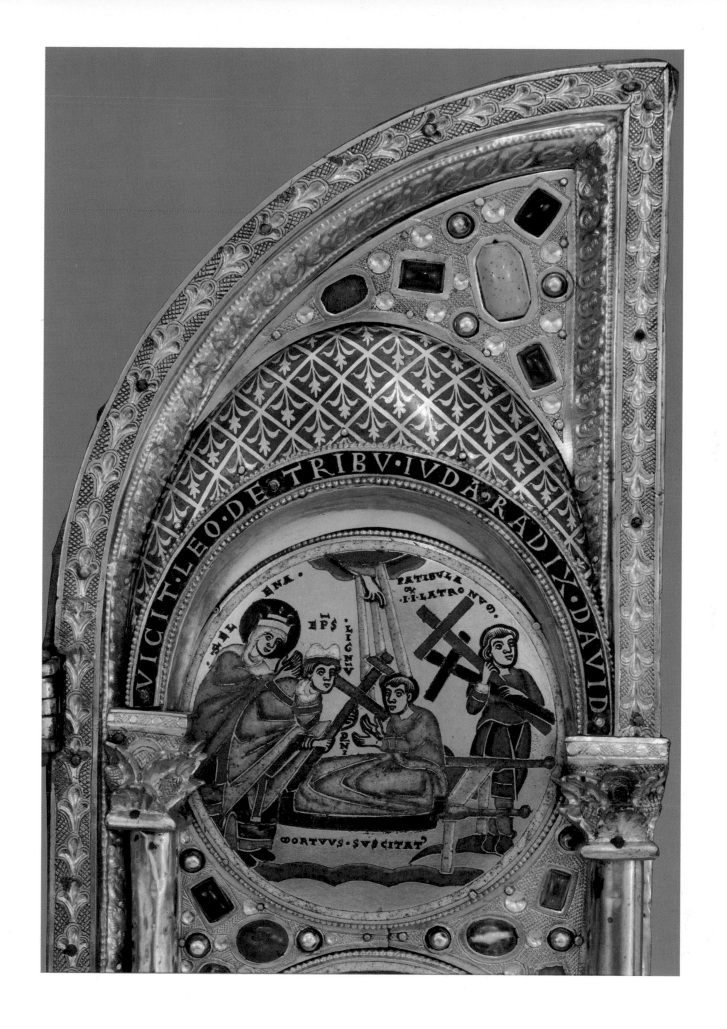

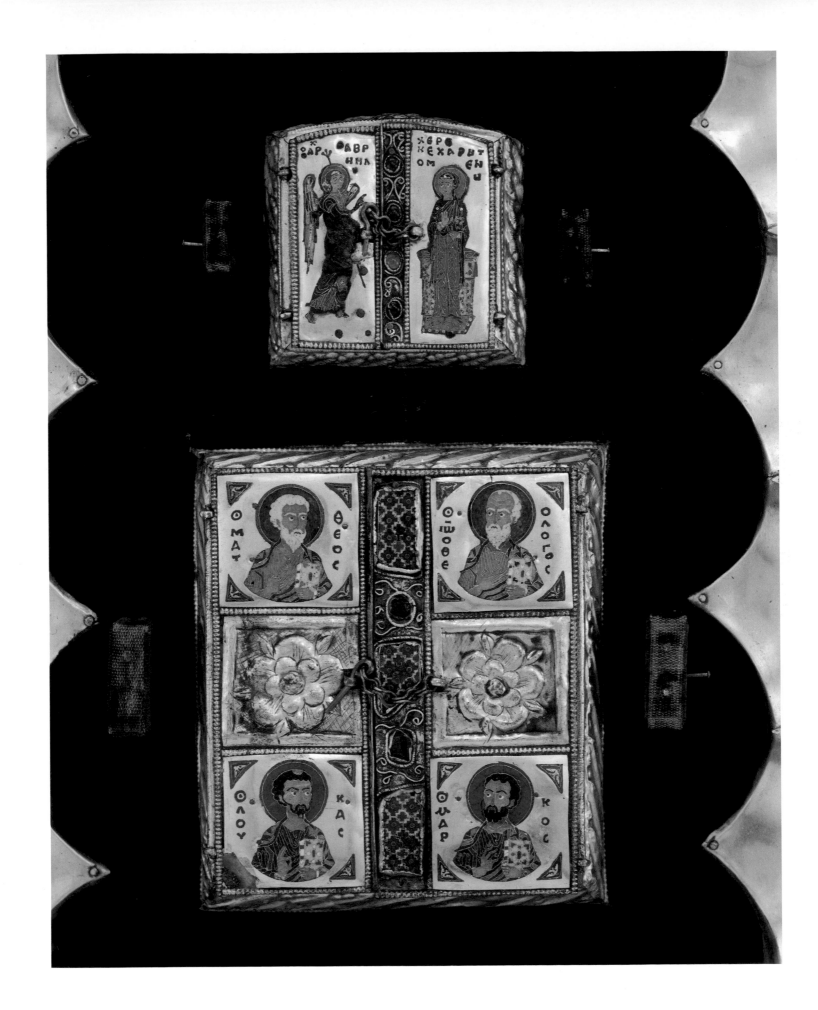

6

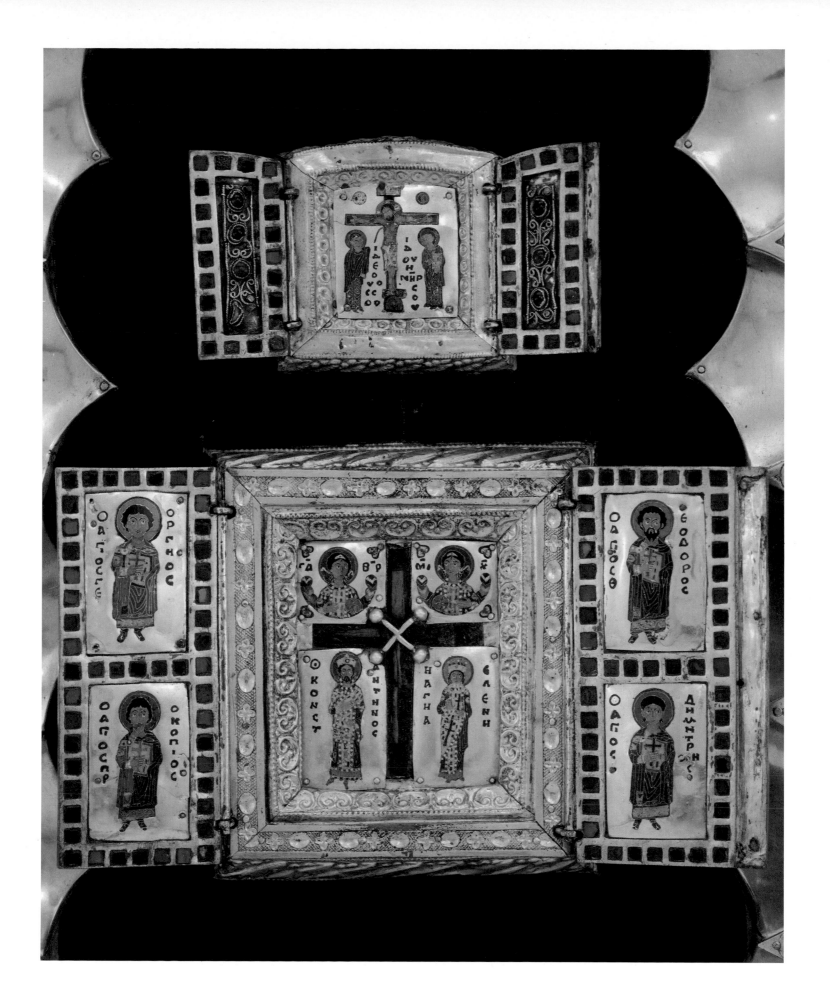

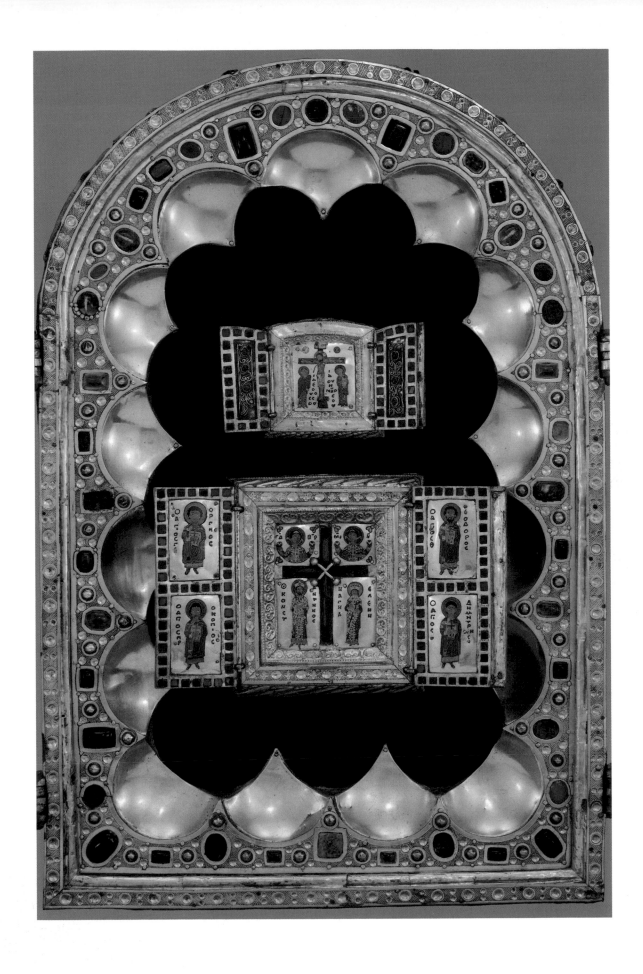

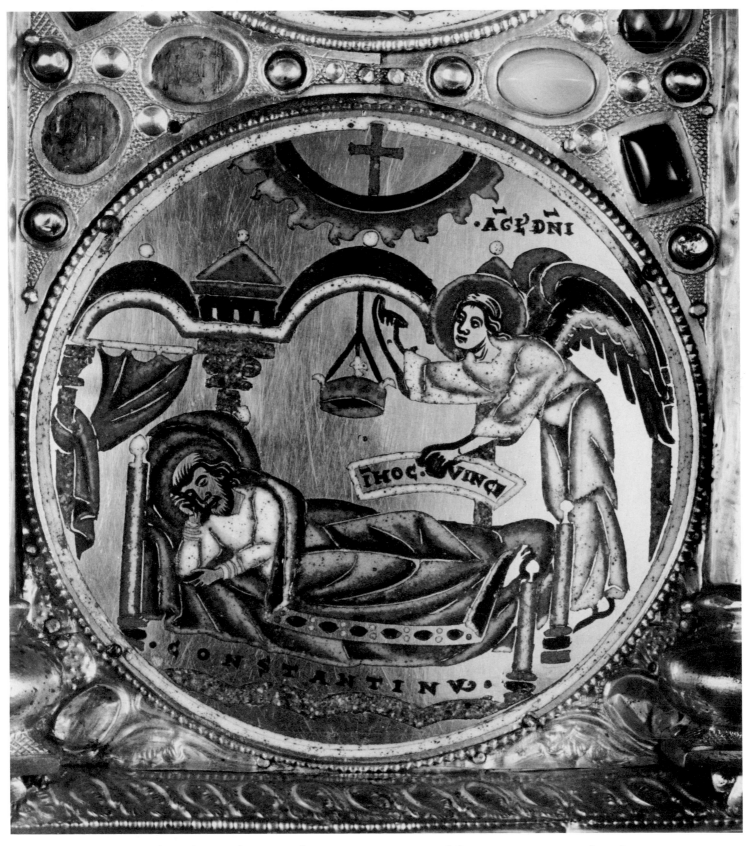

9 Vision of Constantine, from the Stavelot Triptych. Mosan, ca. 1156–1158. (The Pierpont Morgan Library)

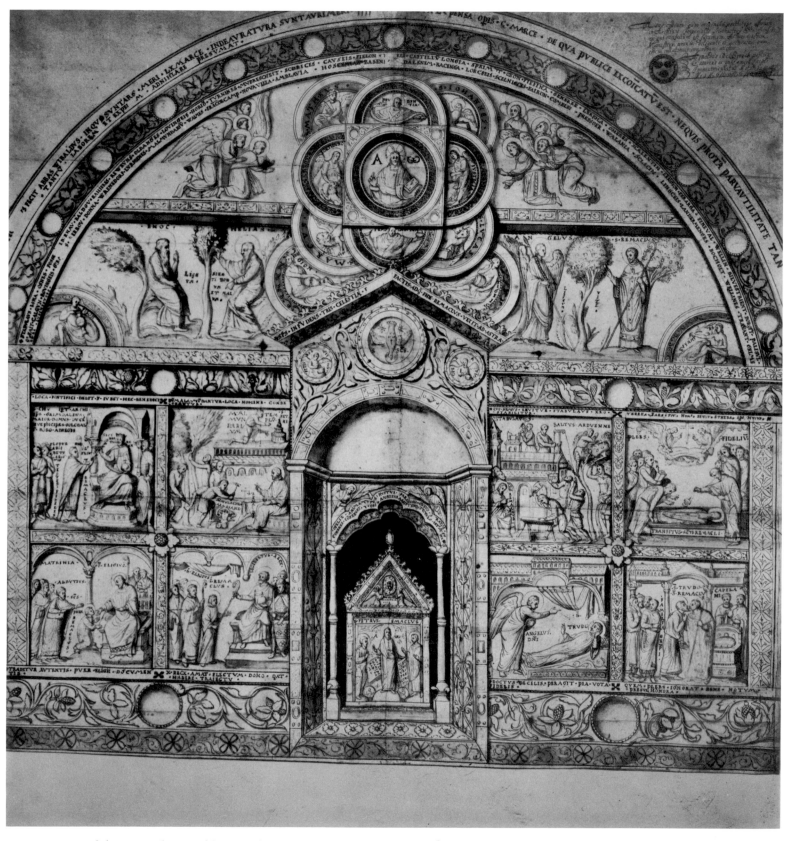

10 Drawing of the Remaclus Retable. Stavelot, 1661. (Liège, Archives de l'État)

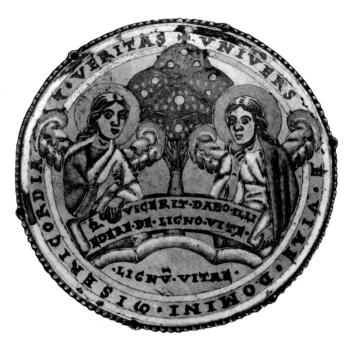

11 Two Angels with the Tree of Life. Mosan, ca. 1160. (Huy, Trésor de la Collégiale Notre-Dame)

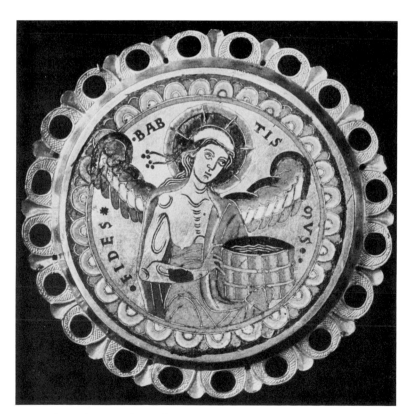

12 *Fides Babtismus*, from the Remaclus Retable. Mosan, ca. 1145–1158. (Frankfurt, Museum für Kunsthandwerk)

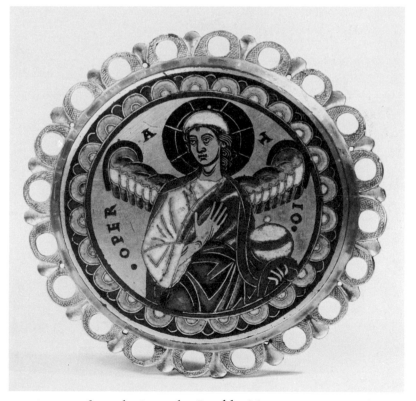

13 *Operatio*, from the Remaclus Retable. Mosan, ca. 1145–1158. (Berlin, Kunstgewerbemuseum)

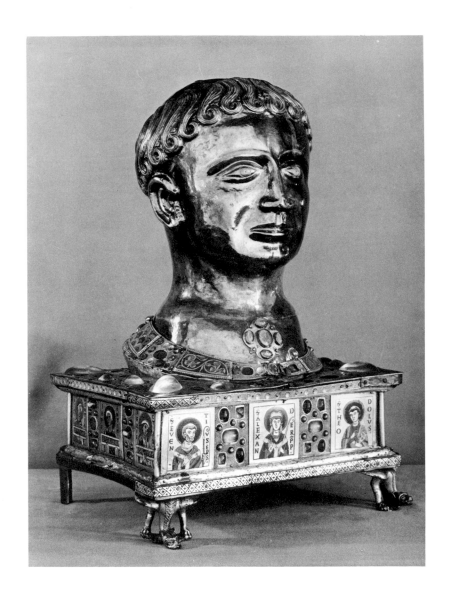
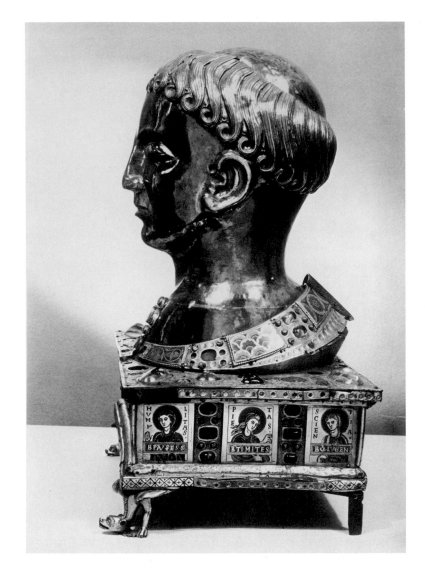
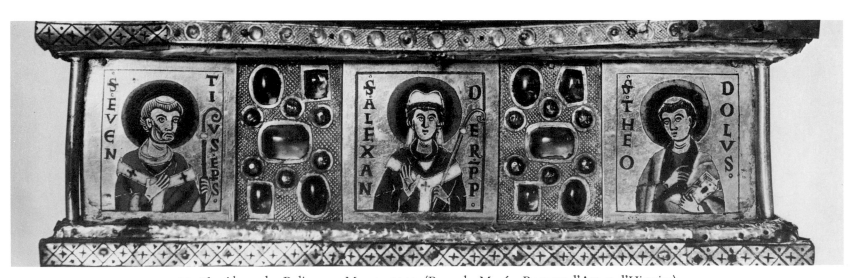

14–16 Alexander Reliquary. Mosan, 1145. (Brussels, Musées Royaux d'Art et d'Histoire)

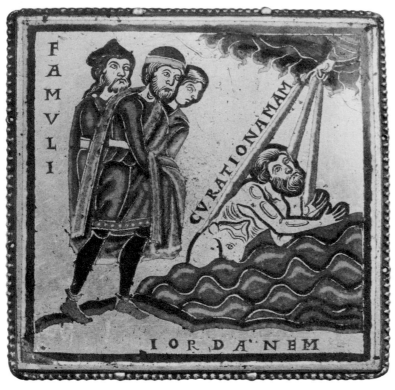

17 Naaman Cured of Leprosy. Mosan, ca. 1160. (London, The British Museum)

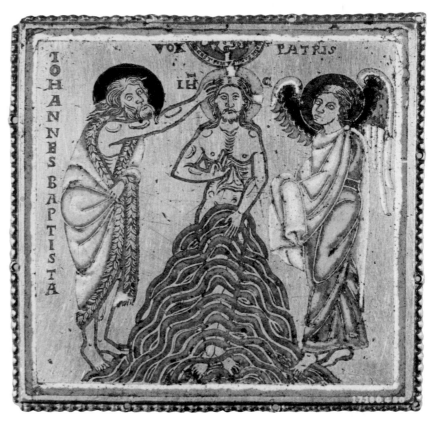

18 Baptism of Christ. Mosan, ca. 1160. (New York, The Metropolitan Museum of Art)

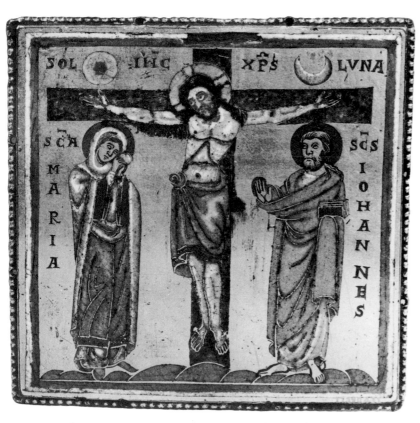

19 Crucifixion. Mosan, ca. 1160. (New York, The Metropolitan Museum of Art)

20 Pentecost. Mosan, ca. 1160. (New York, The Metropolitan Museum of Art, The Cloisters Collection)

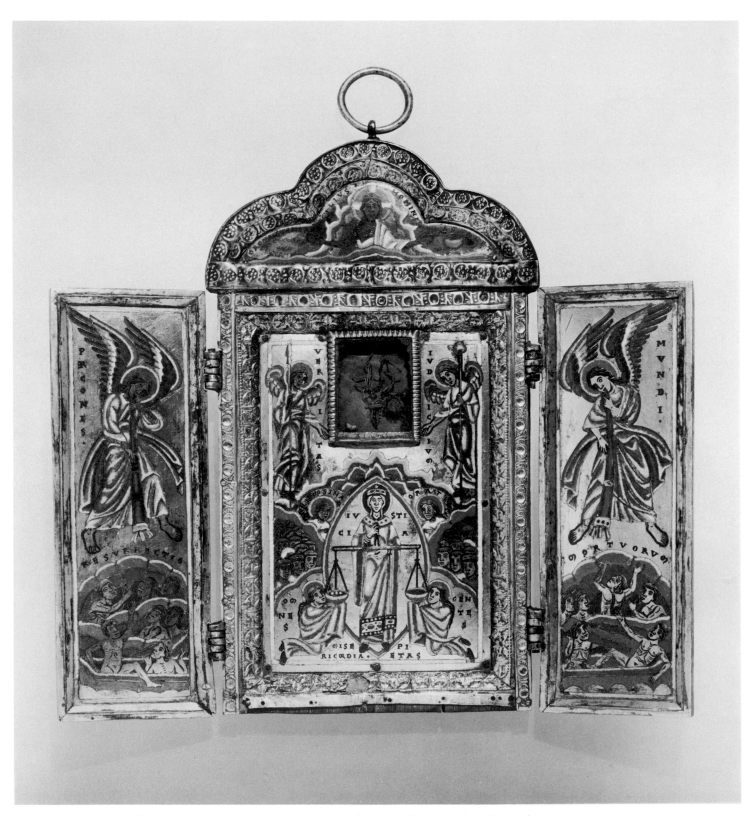

21 Reliquary Triptych of the True Cross. Mosan, ca. 1160. (New York, Private Collection)

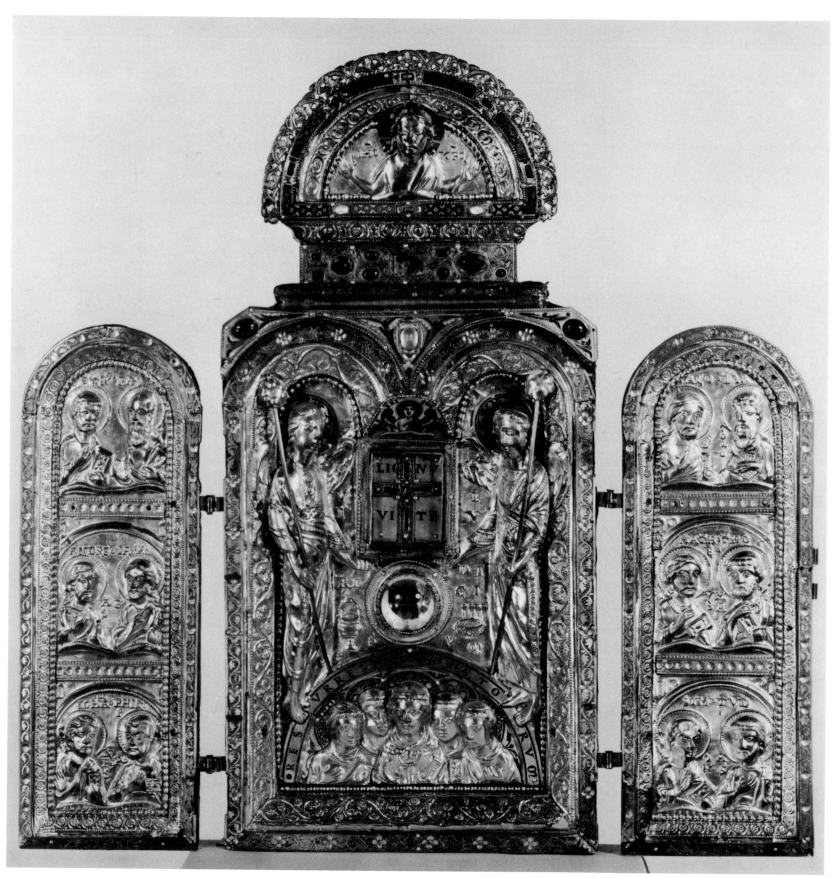

22 Triptych of the True Cross. Mosan, ca. 1160. (Liège, Trésor de l'Église Sainte-Croix)

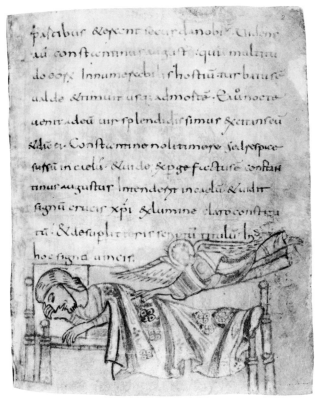

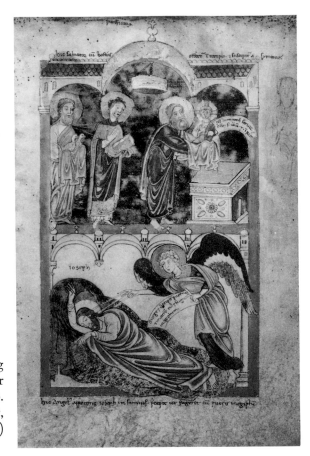

23 Vision of Constantine, from the Wessobrunn Prayerbook. South Germany, early ninth century. (Munich, Staatsbibliothek, Clm.22053, fol. 2)

24 Presentation, Angel Appearing to Joseph; from the Mosan Psalter Fragment. Mosan, ca. 1160. (Berlin, Kupferstichkabinett, 78A6, fol. 7)

25 Battle scene, from the "Life and Miracles of St. Edmund." Bury St. Edmund's, ca. 1130. (The Pierpont Morgan Library, M.736, fol. 7ᵛ)

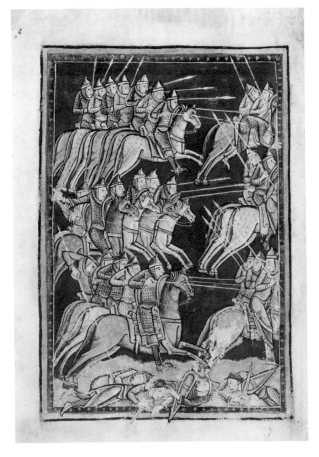

26 Engraving of the Crusade Window at Saint-Denis. (Montfaucon, Les monuments de la monarchie française, I, Paris, 1729, pl. L)

hic abraam cu ccc urnactis suis libauit loch regesq: sodomor cu oi substantia cor

27 Abraham Pursuing the Hostile Kings, from the Mosan Psalter Fragment. Mosan, ca. 1160. (Berlin, Kupferstichkabinett, 78A6, fol. 1 ᵛ)

28–29 Horseman Transfixing a Serpent, a gem from the Stavelot Triptych, with its impression. Late Antique or Early Christian.

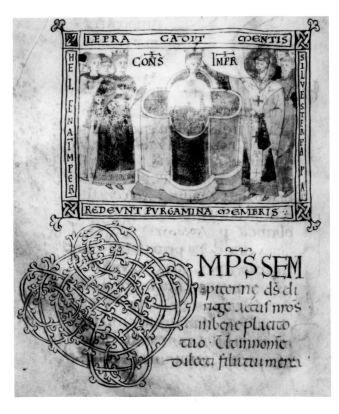

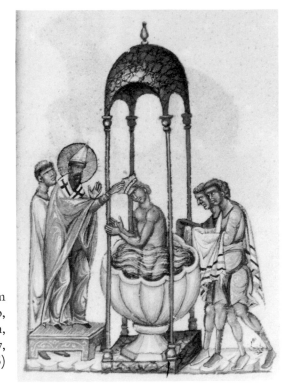

30 Baptism of Constantine, from the Warmundus Sacramentary. North Italy, ca. 1000. (Ivrea, Biblioteca Capitolare, Cod. 86, fol. 23ᵛ)

31 Baptism of Constantine, from a Lives of the Saints. Palermo, early fourteenth century. (Turin, Biblioteca Nazionale, MS.I.II.17, fol. 26)

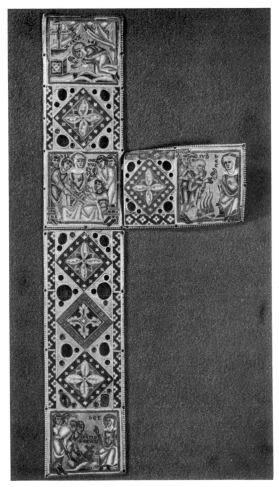

32 Baptism of Constantine, from the Stuttgart Passional. Hirsau, ca. 1130. (Stuttgart, Landesbibliothek, Cod. 57, fol. 167ᵛ)

33 The Beuth–Schinkel Cross. Mosan, ca. 1165. (Berlin-Köpenick, Kunstgewerbemuseum)

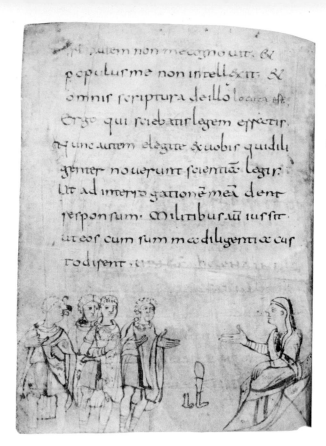

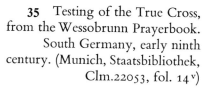

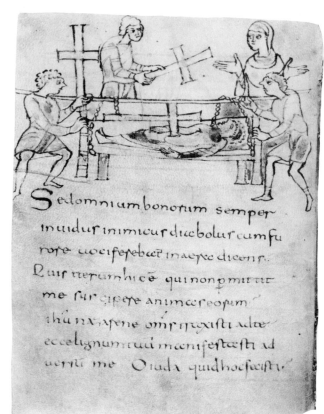

34 Helena Interrogating the Jews, from the Wessobrunn Prayerbook. South Germany, early ninth century. (Munich, Staatsbibliothek, Clm.22053, fol. 6ᵛ)

35 Testing of the True Cross, from the Wessobrunn Prayerbook. South Germany, early ninth century. (Munich, Staatsbibliothek, Clm.22053, fol. 14ᵛ)

36 Helena Interrogating the Jews, Excavation and Testing of the Cross, from a Lectionary. Syria, ca. 1200. (London, British Library, Add. 7169, fol. 12ᵛ)

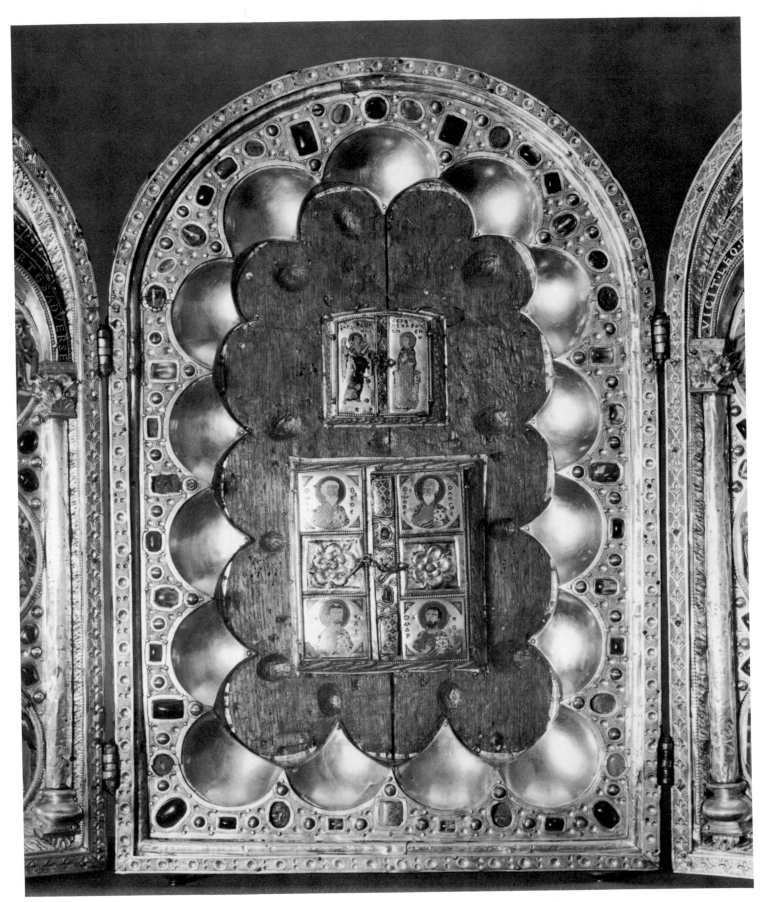

37 Center panel with velvet removed, the Stavelot Triptych.

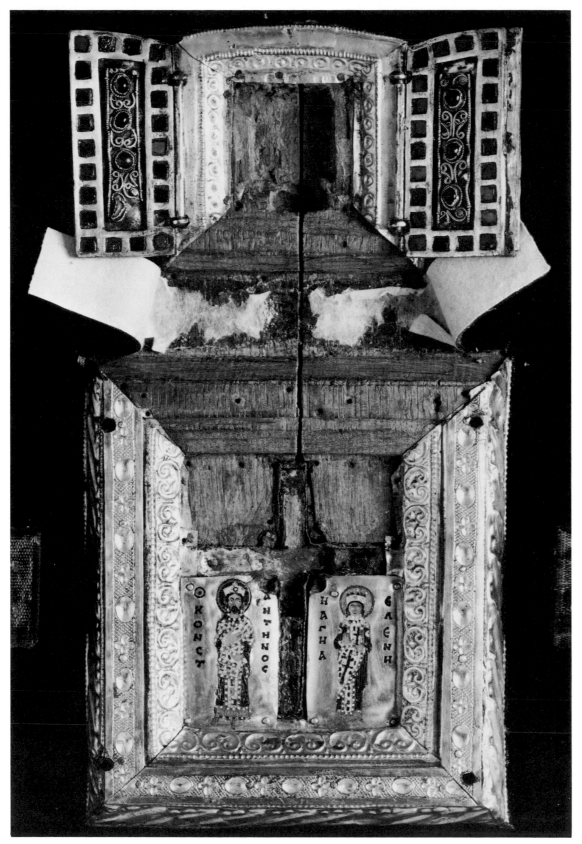

38 The Byzantine triptychs with parts of their frames removed, the Stavelot Triptych.

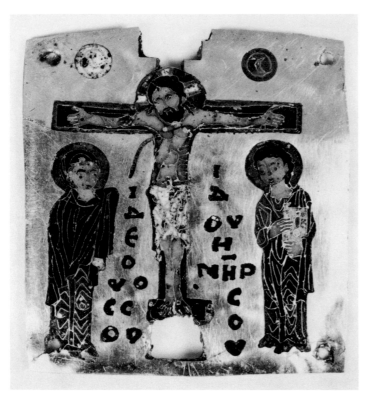

40 "Nail" with pin, from cavity beneath the small Byzantine triptych.

39 Crucifixion enamel removed from the small Byzantine triptych.

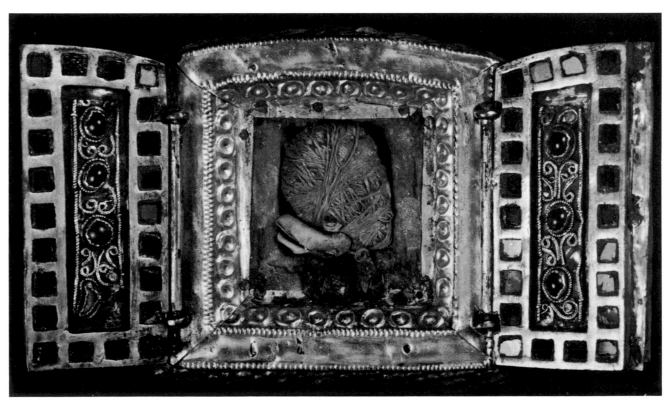

41 Cavity beneath the small Byzantine triptych, before removal of pouch and inscription.

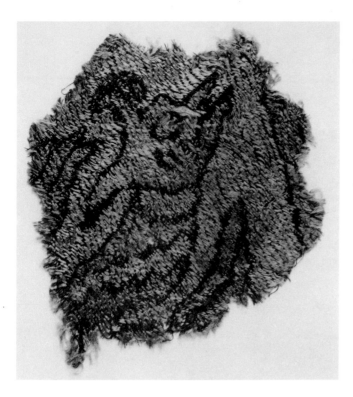

42 Textile of pouch with head of griffin, from cavity beneath the small Byzantine triptych.

43 Inscription, from cavity beneath the small Byzantine triptych.

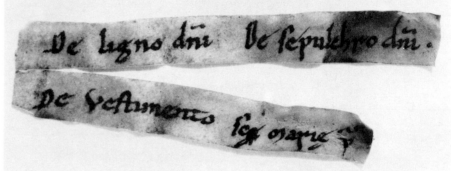

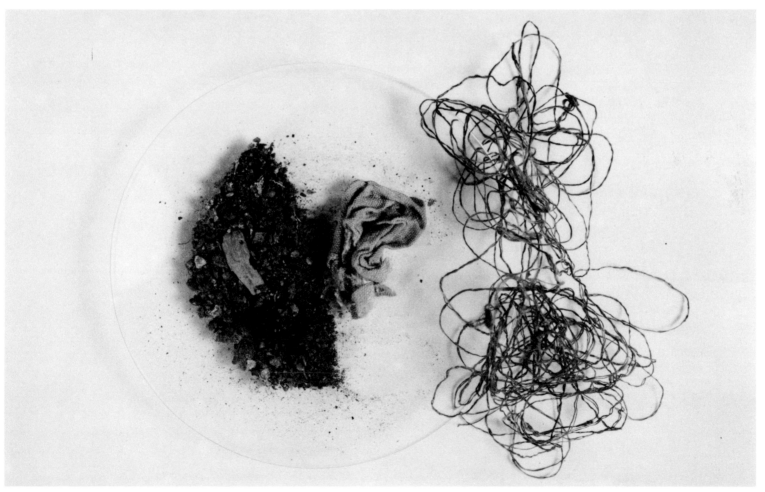

44 Fragments of the True Cross, the Holy Sepulcher, and the Virgin's Garment, contents of pouch from cavity beneath the small Byzantine triptych.

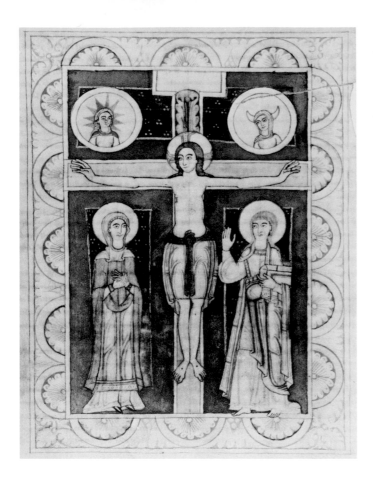

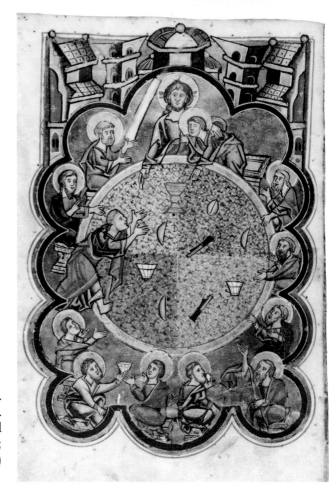

45 Crucifixion, from Wibald's Sacramentary. Mosan, first quarter of the twelfth century. (Brussels, Bibliothèque Royale, MS.2034–2035, fol. 25ᵛ)

46 Last Supper, from a Psalter. Thuringia-Saxony, ca. 1220. (Hamburg, Staats- und Universitätsbibliothek, Cod. 85 in scrinio, fol. 12ᵛ)

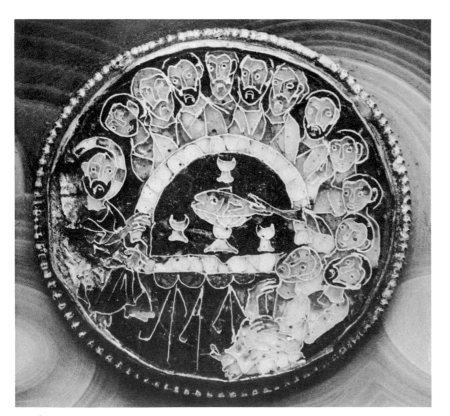

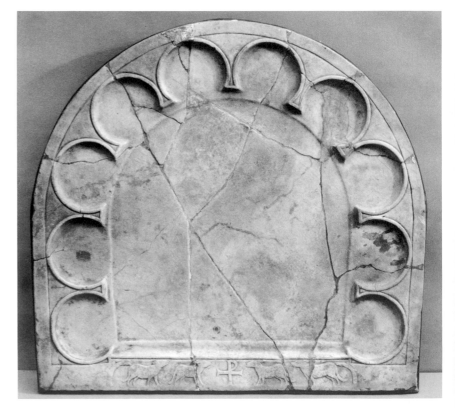

47 Last Supper, from a Paten. Byzantine, tenth century. (Brussels, Stoclet collection)

48 Mensa in *sigma* form. Italy, fifth or sixth century. (New York, The Metropolitan Museum of Art)

49–50 Goddess of Victory, a gem from the Stavelot Triptych, with its impression. Late Antique.

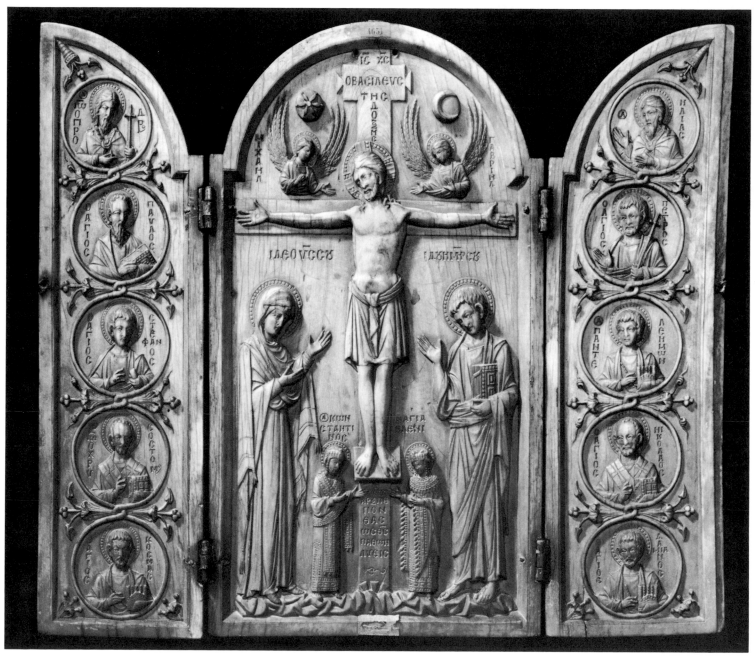

51 Ivory Crucifixion Triptych. Byzantine, ca. 950. (Paris, Cabinet des Médailles)

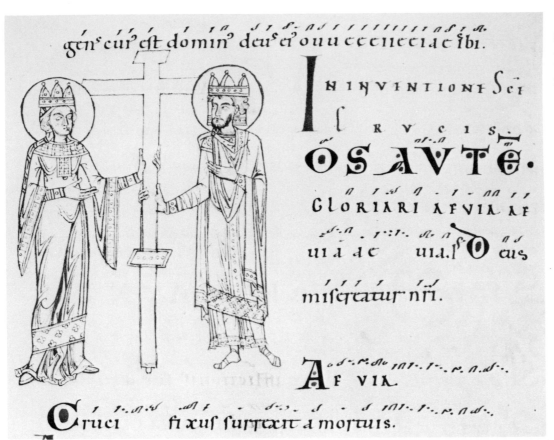

gen cur est domin deus et ou ecc ecciae ibi.

INHINVINTIONE Sci

CRVCIS.

OS AVTE.

GLORIARI AE VIA AE

uia de uia f O eis

miseratur nri.

AE VIA

Cruci fi xus surrexit a mortuis.

52 Helena and Constantine, from the Antiphonary of St. Peter's. Salzburg, ca. 1160. (Vienna, Nationalbibliothek, series nova 2700, p. 338)

inquib: tumistebilir prædicari ir p.

S qui impraeclara saluti peni
inuentione parsionitue. mi
surcitasti. Concede ut uitad ir
præcio. et ne uite. suffragia con
s cu cuncta oboedium creature eto
uerbo tuo-feristi insapientia suppli

53 Judas Digging for the Crosses, from the Gellone Sacramentary. Meaux diocese, ca. 795. (Paris, Bibliothèque Nationale, lat.12048, fol. 76ᵛ)

54 The Vision of Constantine and His Defeat of Maxentius, Helena Interrogating the Jews, the Cross Being Excavated, from the Homilies of Gregory Nazianzus. Constantinople, ca. 880. (Paris, Bibliothèque Nationale, grec.510, fol. 440)

55 Pentecost, from the St. Trond Lectionary. Mosan, ca. 1160. (The Pierpont Morgan Library, M.883, fol. 62ᵛ)

56 Deposition and Entombment, from the St. Trond Lectionary. Mosan, ca. 1160. (The Pierpont Morgan Library, M.883, fol. 51ᵛ)

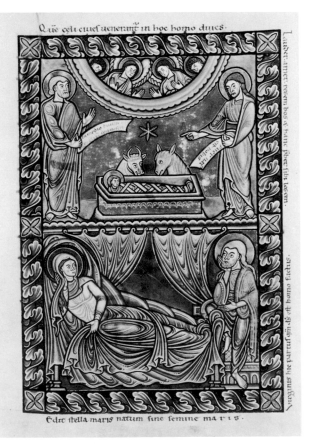

57 Nativity, from the Averbode Gospels. Mosan, ca. 1160. (Liège, Bibliothèque de l'Université, MS.363C, fol. 17)

58 St. Mark and the Lion, from the Averbode Gospels. Mosan, ca. 1160. (Liège, Bibliothèque de l'Université, MS.363C, fol. 57)

59 Heraclius Returning the Cross to Jerusalem, from a Sacramentary. Mont-St.-Michel, ca. 1060. (The Pierpont Morgan Library, M.641, fol. 155ᵛ)

60 Helena Interrogating the Jews, from the Berthold Missal. Weingarten Abbey, ca. 1200–1232. (The Pierpont Morgan Library, M.710, fol. 89)

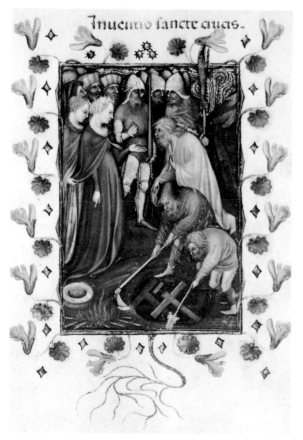

61 Helena Supervising the Excavation of the Crosses, from a Prayerbook. Milan, ca. 1420, by Michelino da Besozzo. (The Pierpont Morgan Library, M.944, fol. 33ᵛ)

62 Queen of Sheba Fording a Stream, from the Hours of Catherine of Cleves. Utrecht, ca. 1440. (The Pierpont Morgan Library, M.917, p. 109)

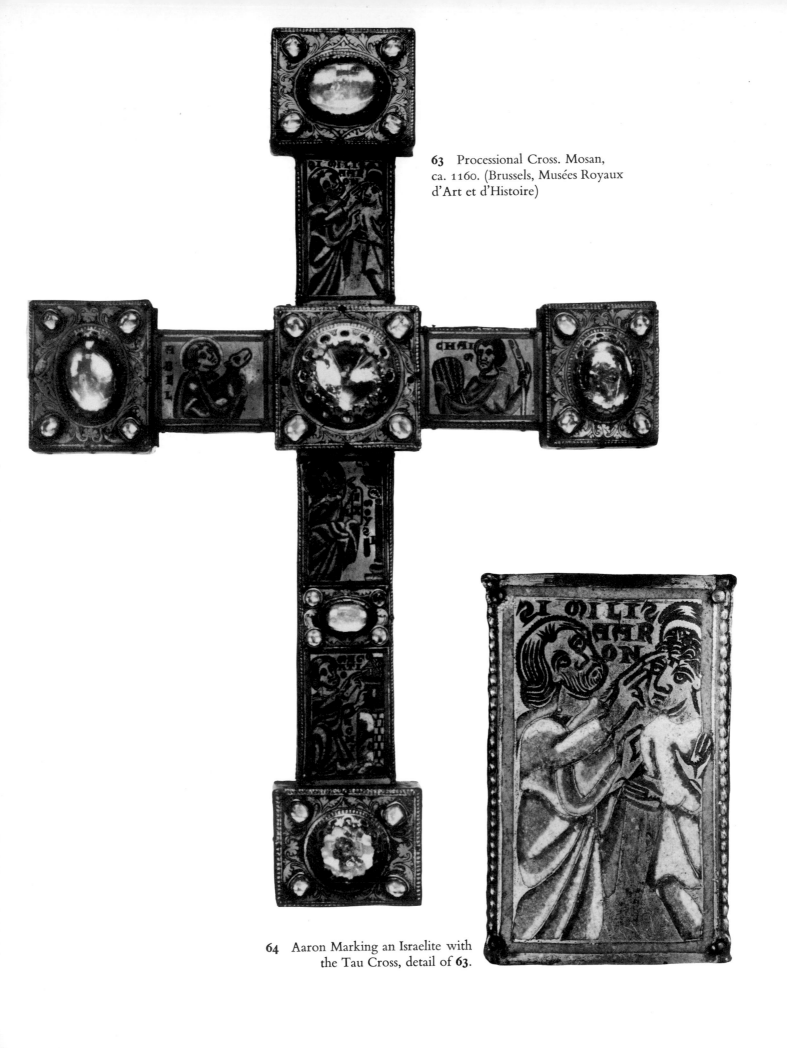

63 Processional Cross. Mosan,
ca. 1160. (Brussels, Musées Royaux
d'Art et d'Histoire)

64 Aaron Marking an Israelite with
the Tau Cross, detail of **63**.

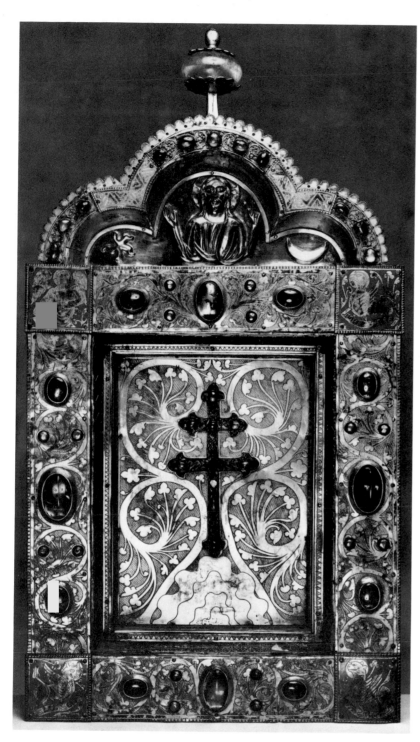

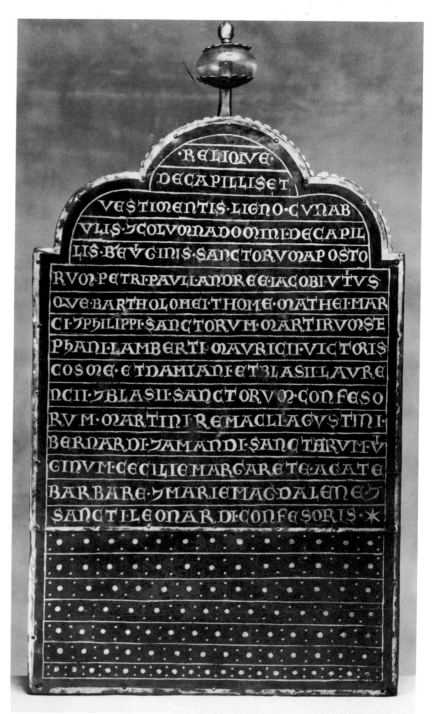

65 Reliquary of the True Cross. Mosan, ca. 1200. (Brussels, Musées Royaux d'Art et d'Histoire)

66 Reverse of **65**.

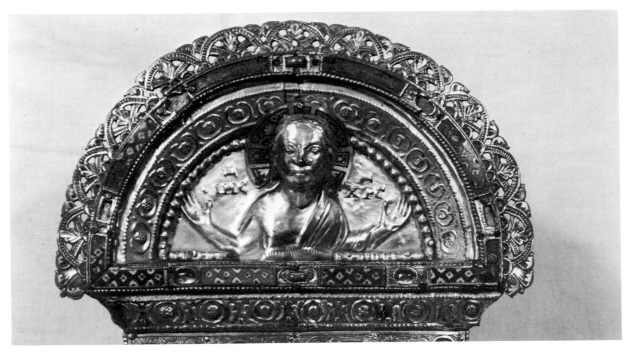

67 Resurrected Christ, detail of **22**.

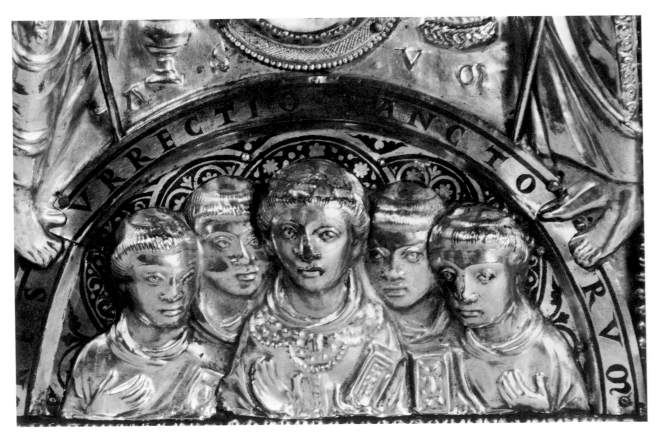

68 Resurrection of Saints, detail of **22**.